TOULOUSE-LAUTREC

AND THE STARS OF PARIS

TOULOUSE-LAUTREC
AND THE STARS OF PARIS

HELEN BURNHAM

with contributions by
MARY WEAVER CHAPIN
and JOANNA WENDEL

MFA Publications | Museum of Fine Arts, Boston

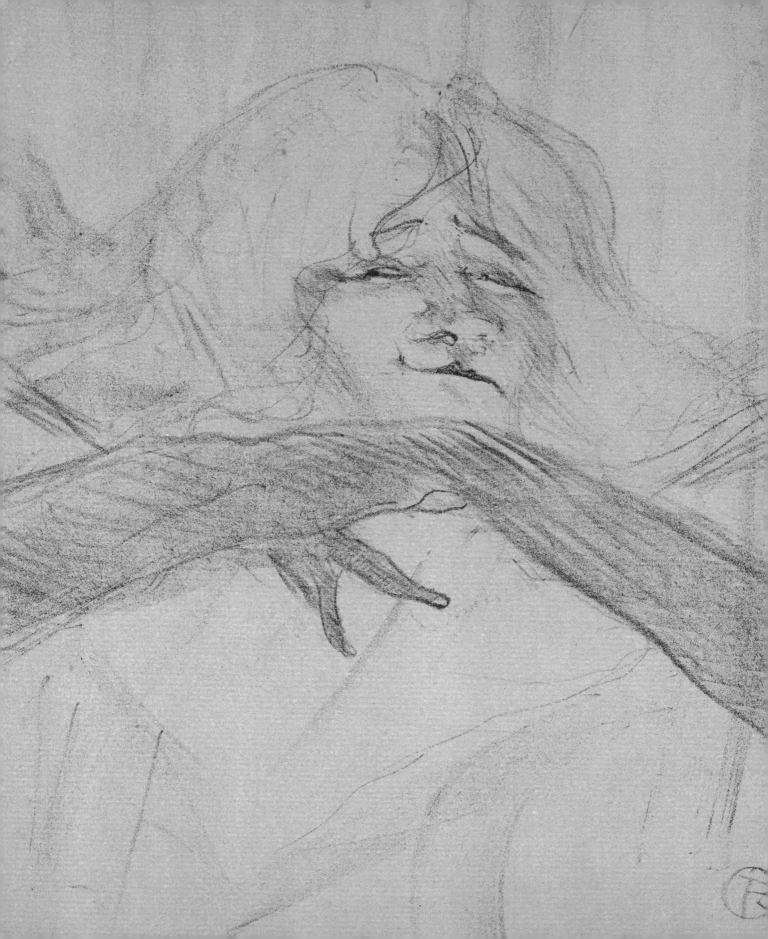

Contents

Directors' Foreword

A DYNAMIC partnership between the Museum of Fine Arts, Boston, and the Boston Public Library is at the heart of this groundbreaking exhibition and related publication. Neighbors on Copley Square from our founding days until 1909, the Museum and Library remain linked by a shared mission of welcoming, engaging, and serving the public. Our longstanding relationship has included frequent loans, a tradition we now expand to include conservation, interpretation, and programming to reach new audiences throughout Boston and beyond.

Toulouse-Lautrec and the Stars of Paris presents a wonderful opportunity to declare again this partnership. Together, we celebrate Henri de Toulouse-Lautrec, one of the most innovative artists of his day. His images of star performers captured the celebrity culture that transformed Paris and especially the bohemian neighborhood of Montmartre in the fin-de-siècle. The exhibition explores that raffish world with more than two hundred rare works in a variety of media from our combined collections, as well as select loans from partner institutions and private collections. This publication illustrates highlights from the exhibition, while focusing on Lautrec's depictions of six leading cabaret stars as well as his brilliant contributions to graphic design and portraiture.

We are delighted to oversee this partnership, and to recognize the generous benefactors who have contributed to the growth of the Lautrec collections at both institutions. Most notable among these have been Albert H. Wiggin at the BPL and W. G. Russell Allen at the MFA. The exhibition is sponsored by Encore Boston Harbor, with additional support from the great-grandchildren of Albert H. Wiggin, the Cordover Exhibition Fund, and anonymous funders.

As Boston experiences dramatic changes to its landscape in the early twenty-first century, we pay tribute to modern Paris. May this historic opportunity to combine our institutional strengths herald a new chapter of civic alliance and creative growth.

DAVID LEONARD
President
Boston Public Library

MATTHEW TEITELBAUM
Ann and Graham Gund Director
Museum of Fine Arts, Boston

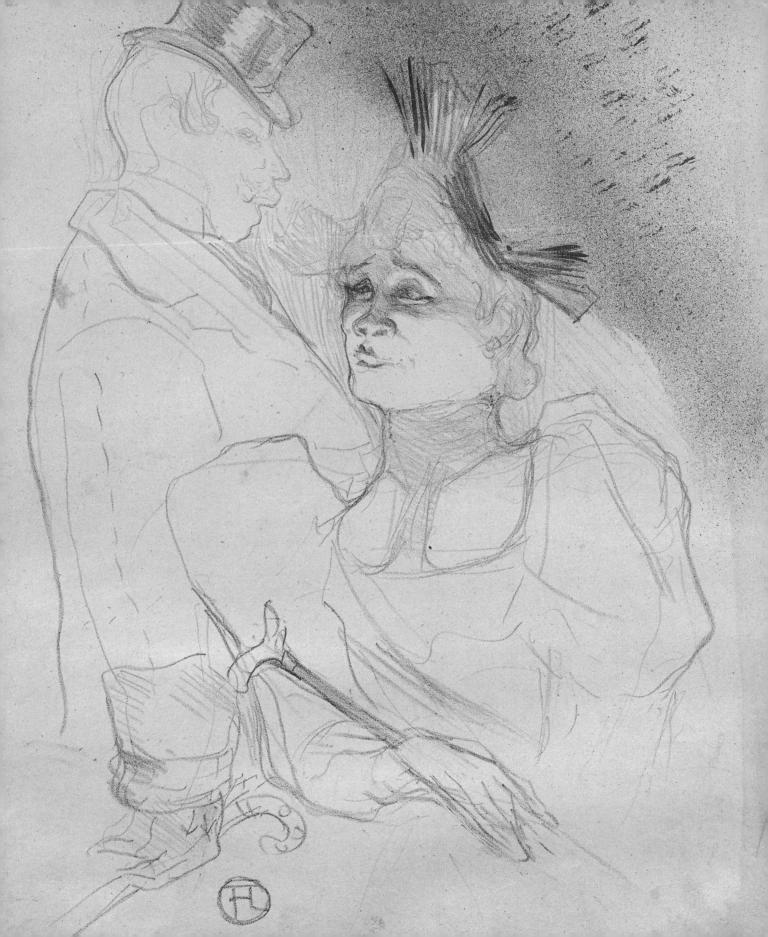

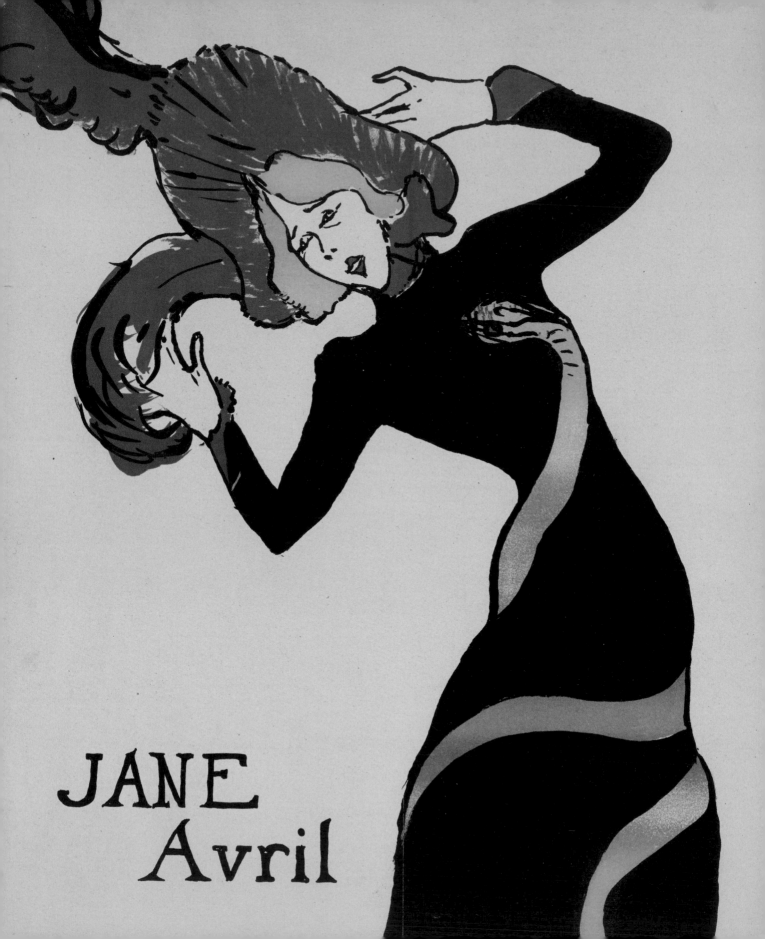

Foreword

MARY WEAVER CHAPIN

HENRI DE TOULOUSE-LAUTREC was the right artist at the right time. The time was fin-de-siècle Paris, a moment when a vast array of entertainment options was springing up around the city, performers were attracting increasing attention and fame, and the color poster and lithograph were reaching new artistic and commercial heights. The artist was Henri-Marie-Raymond de Toulouse-Lautrec-Montfa, the descendant of an old and distinguished aristocratic family from the south of France. Blessed with a quick and witty graphic talent, a keen understanding of performance, and an unusual degree of insight into human behavior, he captured the nightlife of Paris in artworks that are original, dazzling, and remarkably perceptive.

Although Lautrec's mature professional career lasted a mere fifteen years, he created approximately one thousand paintings and watercolors, nearly five thousand drawings, and more than three hundred and fifty prints and posters. Among this substantial oeuvre, his finest images, perhaps, are his depictions of the celebrities of the stage, "les stars." The burgeoning fascination with public celebrities had begun earlier in the century and was fed by new technology, such as lithography and photography. After the middle of the nineteenth century, images of actors, dancers, and performers of all varieties could be seen in shop windows, purchased by fans, and viewed in three dimensions through stereoscopes. Collectors created albums focusing on particular stars or private portfolios of erotic poses by cancan dancers and circus performers, bringing the public performer into the private domestic world. The development of large-scale color lithography was another milestone; by the 1880s, bright posters dominated the streets of Paris, advertising everything from the most elevated opera to gritty *cabarets artistiques*. Publishing flourished following the Law on the Freedom of the Press of 1881, leading to a proliferation of journals, magazines, newspapers, and novels, many of which focused on the entertainers of the day. Niche publications devoted their pages to "les interviews" with stars, a new feature borrowed from American popular culture (along with the name), and café-concerts and cabarets such as the Chat Noir published their own specialized periodicals to reach fans. Celebrity endorsements, so common in our twenty-first-century world, accompanied the birth of modern advertising, as stars of the day lent their names to such products as face powder and canned sardines.[1]

This celebrity-mad world was the stage that Lautrec stepped onto when he settled in Paris,

in the 1880s, to pursue his artistic career. The graphic arts, particularly lithography — employed for large color posters and smaller, deluxe prints created for collectors — fueled the boom in celebrity culture. Lautrec was especially well suited to this medium, which showcased his preternaturally gifted draftsmanship. Moreover, perhaps the relative newness of lithography, which was not yet burdened with centuries of artistic conventions, encouraged him to experiment, employing bold, overlapping colors, fine sprays of ink, and arresting compositional perspectives that appeared fresh and modern to contemporaries' eyes. Lautrec's watershed poster *Moulin Rouge: La Goulue* of 1891 made his name and linked him with the stars of Parisian nightlife (see fig. 4). Over the following decade, Lautrec produced another twenty-nine posters and hundreds of deluxe lithographs depicting the acrobats, dancers, actors, and singers who populated the city's world of entertainment. Critics praised his vision; one called him an artist "with more to say than the others and who says it unhesitatingly in a language all his own." Ernest Maindron, a leading proponent of the artistic poster, echoed that sentiment, writing, "It is a new language that this philosopher speaks, but he has studied well what he writes, and he writes it in a striking manner."[2]

It is telling that Maindron refers to Lautrec as a philosopher. Other critics pointed to Lautrec's ability to capture the surface appearance of the stars he depicted, while hinting at the personality behind the carefully crafted stage persona. This interstitial realm between the public and the private, the candid and the performed, was Lautrec's true home. His close relationships with the people he depicted added to this sense of intimacy, along with his keen insight into others.[3] Perhaps his own liminal and contradictory status — straddling an aristocratic birth and a penchant for lowlife, a love of extreme gesture and dance countered by a painful physical condition that limited his own movement — allowed Lautrec to see into the cracks between his subjects' inner and outer lives. Gustave Coquiot, the artist's friend and insightful critic, noted that he had a mystical ability to see past surfaces. Lautrec, he asserted, "was like the Buddha, the Buddha in a bowler hat, the Buddha of the quadrille and the waltz. But this was a Buddha who saw everything and observed everything and who registered the most complete collection of gestures and postures imaginable."[4]

Lautrec's keen perception coupled with his prodigious artistic talents made him uniquely attuned to the craft of celebrity in fin-de-siècle Paris. Whether he was depicting the iconic pose and costume of the singer Aristide Bruant, the extreme and supple dance movements of Jane Avril, or Marcelle Lender's sensuous back, Lautrec brought both wit and bravura to his portrayals of performers. This gallery of the stars he fixed on paper celebrates the enduring work of a perceptive artist and the cultural moment he immortalized.

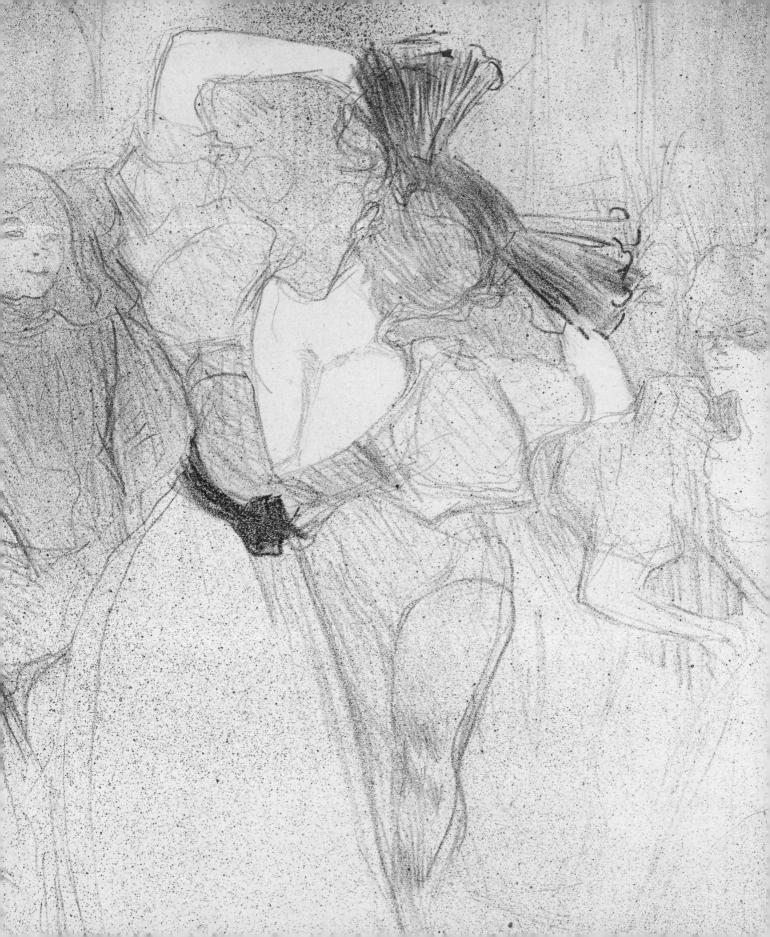

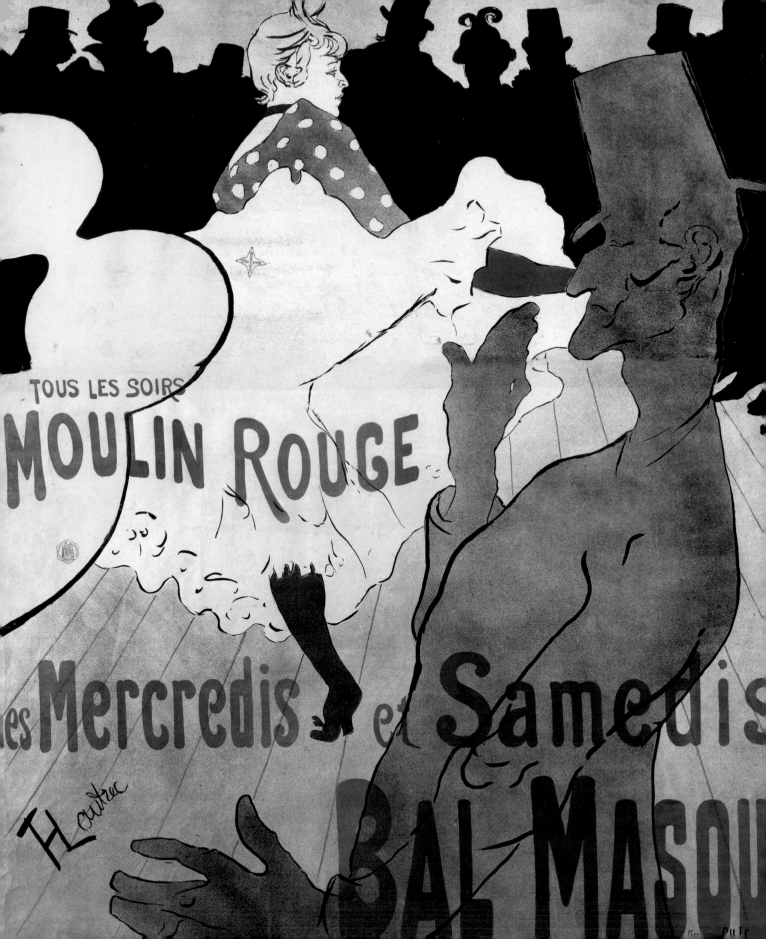

Spectacular and Subtle: The Art of Toulouse-Lautrec

HELEN BURNHAM

HENRI DE TOULOUSE-LAUTREC lived for much of his adult life in Montmartre, the bohemian center of Paris nightlife, where he socialized with friends from all levels of society (fig. 1).[1] Despite suffering from an affliction that kept him in nearly constant pain, he produced a great variety of accomplished and ground-breaking imagery that expressed a longstanding interest in the habitués of his raffish quarter. His posters and prints in particular focused on the stars of Montmartre nightlife,

Fig. 1. Paul Sescau
(French, 1858–1926),
Henri de Toulouse-Lautrec,
about 1892

capturing in pithy and unforgettable compositions the defining gestures, costumes, and expressions of performers whose eccentricities and transgressions were part-and-parcel of their appeal to an audience tantalized by extremes of emotion and behavior. Lautrec combined acute awareness of the visual cues of stardom with sensitivity to the idiosyncrasies of his subjects, many of them personal friends. His graphic work is renowned for bold colors and radical compositions, while retaining an unexpected level of delicacy and subtlety, and relaying a sense of the interior lives of public figures along with the spectacle of their often shocking performances.

Lautrec's interest in types representative of Montmartre counterculture characterizes his paintings of the late 1880s and early 1890s.[2] In two important examples, he posed friends in the guise of down-and-out characters in seedy drinking establishments. *At the Café La Mie* features Maurice Guibert, an amateur photographer and champagne merchant, with his mistress, Mariette Berthaud (fig. 2).[3] The painting's title is a play on slang for lower-class women and for clients who fail to pay prostitutes.[4] *The Hangover (Suzanne Valadon)* portrays Lautrec's mistress — who would later become an artist in her own right — posing as a woman nursing a drink alone in a café (fig. 3).

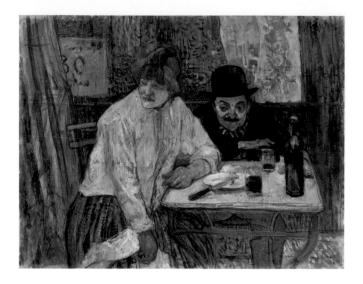

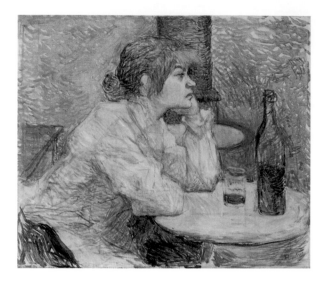

The solitary woman drinking signaled the social status of a prostitute or some other type of dissipated woman, and the subject alluded to the growing health crisis of alcoholism in Paris at this time.[5] The critic Théodore Duret wrote of the couple in *At the Café La Mie*, "In their horror, we cannot but admire them," encapsulating a feeling that many of Lautrec's works elicit: the frisson of seeing something both disturbing and seductive, characters that might in other circumstances elicit pity or lust, but in this artist's hands preserve an almost aggressive self-containment.[6]

Henri de Toulouse-Lautrec's first poster, *Moulin Rouge: La Goulue*, is big and dramatic, but like his quieter works in other media it presents an insightful and somewhat disquieting perspective on its subject (fig. 4). Commissioned by the infamous dance hall Le Moulin Rouge, where Toulouse-Lautrec had been a patron since its opening in 1889, the poster advertises the star performer Louise Weber, known as La Goulue (the glutton), with in-your-face, sex-sells immediacy. Yet it also suggests in a more subtle way the psychology of being a celebrity, of cultivating a particular look and repeating a signature performance at

the lonely center of a shadowy crowd. While Louise Weber dances the *chahut*, a rowdy version of the cancan that scintillated and scandalized audiences, she wears an expression that is matter-of-fact, jaded, or tired, or perhaps, some combination of all three.[7] She certainly does not exude the exuberance of the generic beauties selling champagne and other sundries on advertising posters by Lautrec's contemporaries.[8] Her only recognizable companion in the otherwise faceless crowd is the dancer Valentin le Désossé ("the boneless"), another performer in Montmartre, whose unusual physiognomy is flattened in the foreground and positioned between her legs; his right thumb points to her sex, and the fingers of his left hand are similarly erect and suggestive.

The poster radically synthesizes artistic devices from a range of sources to achieve its innovative effect. The broad planes of color, bold silhouettes, and flattened space resemble elements in Japanese woodblock prints. Lautrec's adoption of these devices set a new standard for poster design that was followed by other artists of the bohemian Montmartre scene, who advertised all manner

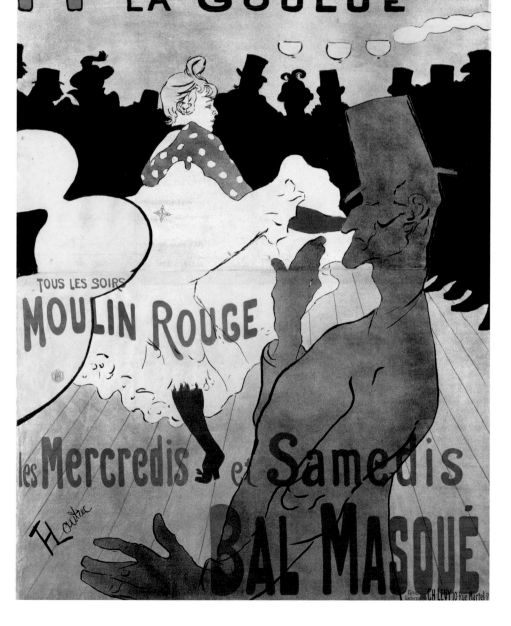

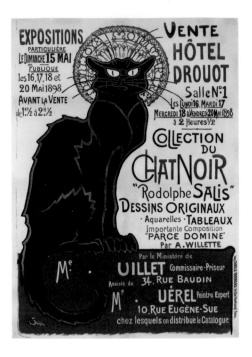

of clubs, identified by a range of terms. With a typical nineteenth-century zeal for classification, terms for sites of entertainment included *guingette* (after the term for a country drinking spot, as a reference to Montmartre's recent past as a rural suburb of Paris), *bal* (a ballroom, many of which were located on the Left Bank of the Seine), *café-concert* (an upscale nightclub with performers, often found on the Right Bank), and *cabaret* (a performance space offering ample alcohol, associated with Montmartre). The Moulin Rouge was a bit of all of these: a dance hall with a drinking garden and a performance space, located at the edge of Montmartre, not too far from more respectable neighborhoods on the Right Bank.

The shadowy figures in the background of *Moulin Rouge: La Goulue* bring to mind the shadow-theater productions held at Le Chat Noir, the first cabaret in Montmartre, where Lautrec met the performer and impresario Aristide Bruant. The Chat Noir, immortalized in a poster by Lautrec's contemporary Théophile

Steinlen, set an anything-goes tone for Montmartre with irreverent performances of songs, plays, readings, and parades, all for an audience that included artists and their patrons (fig. 5). Its shadow theater, designed by the artist Henri Rivière, presented sophisticated cut-out figures with bold shapes and expressive silhouettes, placing them against painted backgrounds and enhancing the performance with lighting and sound effects to produce a spectacle that influenced artists working in a range of media.[9]

With his 1891 entry into the fray of advertising and celebrity culture, Toulouse-Lautrec joined the rising phenomenon of the poster craze or *affichomania*. From the late nineteenth century into the twentieth, posters could be seen all over Paris (fig. 6). They appeared along the newly constructed grand boulevards as well as on kiosks, urinals, and cylindrical "Morris columns" made specifically to display posters.[10] The poster *Moulin Rouge: La Goulue* was mounted on a cart that was pulled around the city, as well as displayed at the nightclub itself.[11]

Most posters were produced using the printmaking technique of lithography, in which an artist makes a design with greasy crayons or inks on finely polished limestone slabs or metal plates (less common in Lautrec's day).[12] After a chemical process affixes the marks to the surface, the stone or plate is moistened and then inked. The wet areas repel the ink and the greasy marks attract it, becoming the areas that print when a sheet of paper is pressed against the stone. Typically in color lithography, multiple stones are used, one for each color. Lautrec worked closely with professional printers and experimented with the juxtaposition of colors. He became extremely adept at the use of *crachis*, a splatter technique that creates a soft tonal effect.[13]

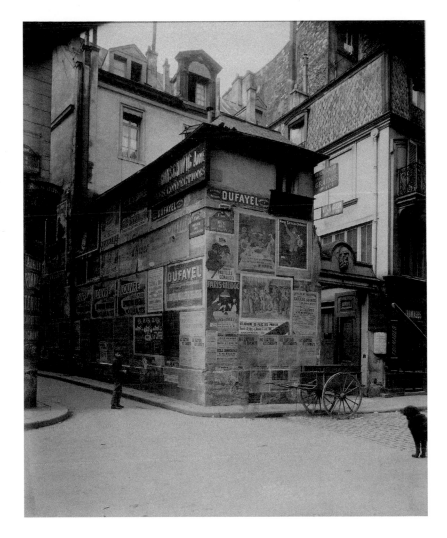

Fig. 6. Jean-Eugène Auguste Atget (French, 1857–1927), *39, rue des Bourdonnais, Maison de la Barbe d'Or*, about 1896

These lithographic prints and posters found a market of passionate collectors, who sometimes housed their collections in specialized print cabinets.[14] City dwellers used their disposable income to cultivate personal interests and decorate their surroundings. Those who could not afford a limited-edition print, never mind a unique painting, could pull down a poster freshly glued to a city wall and take it home to tack up on the wall or add to a growing stack in a portfolio. The appetite for collecting all manner of things, including prints and posters, can be seen as related to a growing bourgeois preoccupation with the life

of the mind and the cultivation of individual character.

Intensified modes of subjectivity marked the visual arts. The ability to represent extreme emotional and physical states had long been a specialty of caricaturists. From an early age, Lautrec emulated the humor, wit, and exaggeration associated with such master satirists as Honoré Daumier (fig. 7). This legacy is particularly evident in Lautrec's views of performers in the series *Le Café-Concert*. In an image of Nicolle, a performer at the theatrical venue Gaieté Rochechouart, Lautrec emphasizes the glare of artificial stage lighting, a visual cue of modernity (fig. 8).[15] The effect intensifies the two-dimensionality of her figure, the improbability of her vertical hairdo, and the almost feral expression created by her upturned nose and squinting eyes. Like the figure of Désossé in the poster *Moulin Rouge*, Nicolle becomes a near cypher in the spotlight, intensified on stage into an ominous, spectral character.

In contrast, Lautrec's print portfolio *Elles* adopts a more intimate perspective, while still showing the artist's interest in manifestations of emotion in the context of performance. These twelve views of brothel life focus almost entirely on the domestic activities of the women inhabiting brothels, rarely featuring a male customer (although the point of view, of course, is male).[16] Women whose lives were spent in a kind of theater for customers appear here as sentient beings, with habits and relationships. In one lithograph from the series, a young woman in bed and her mother commune; and in a remarkable painting of a similar subject, two women make their bed — a behind-the-scenes moment that turns a humanizing lens on subjects more often seen as sex objects, or as menaces to morality (fig. 9).[17]

Only one print in the *Elles* portfolio portrays

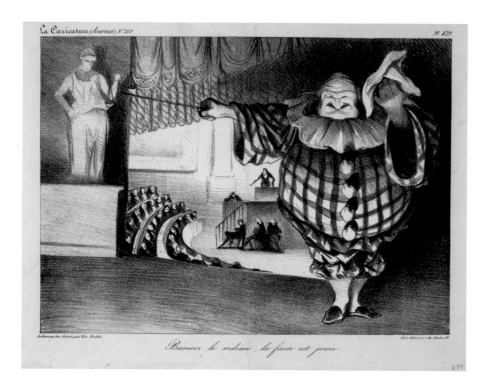

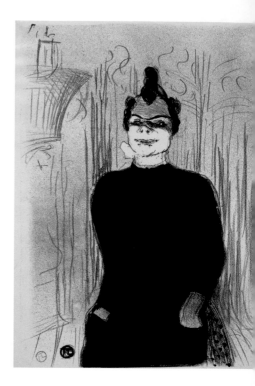

Fig. 7. Honoré Daumier (French, 1808–1879), *Bring Down the Curtain, the Farce Is Over*, 1834

Fig. 8. *At the Gaieté Rochechouart: Nicolle*, 1893

Fig. 9. *Two Women Making Their Bed*, 1891

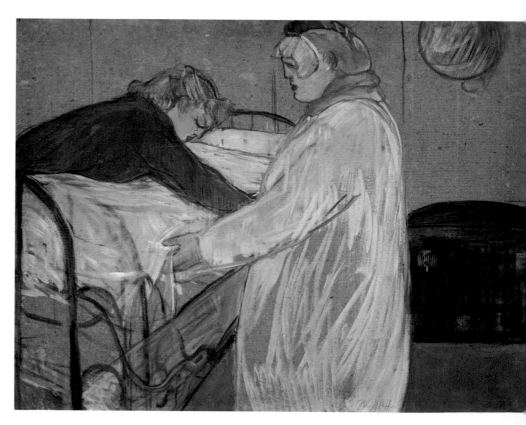

Fig. 10. *Seated Clown at the Moulin Rouge (Mademoiselle Cha-U-Ka-O)*, 1896

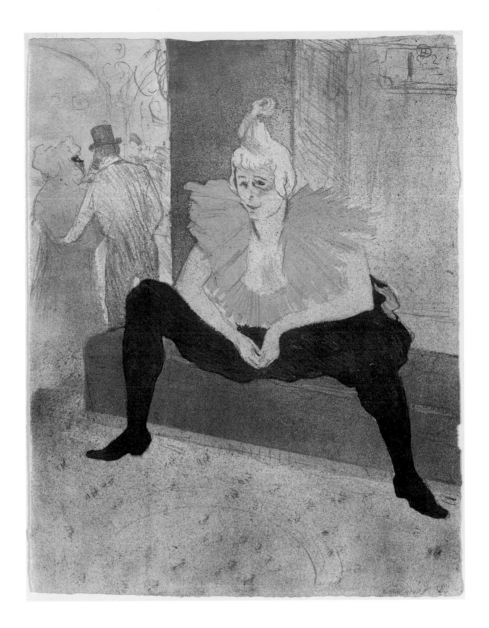

an actual stage performer, the clown Cha-U-Ka-O, so named for her particularly wild version of the *chahut* dance (fig. 10). It is one of the more affecting works Lautrec produced. Here he combines the deeply sympathetic perspective of the *Elles* series with the trappings of Montmartre stardom to depict the energetic dancer in a brief moment of offstage respite, or ennui. The image is at once about fame and its costs, about public and private selves, offering an intimate view of a private moment for the clown in her jaded glory.

Lautrec's depictions of celebrities contributed to their fame by distributing their images in posters and prints to an eager audience. With expressive lines, succinct forms, brazen colors, and telling exaggerations, he pushed his art in new directions to capture the look that defined a performer in the public eye, while focusing on the person as much as on the role.

TOULOUSE-LAUTREC

AND THE STARS OF PARIS

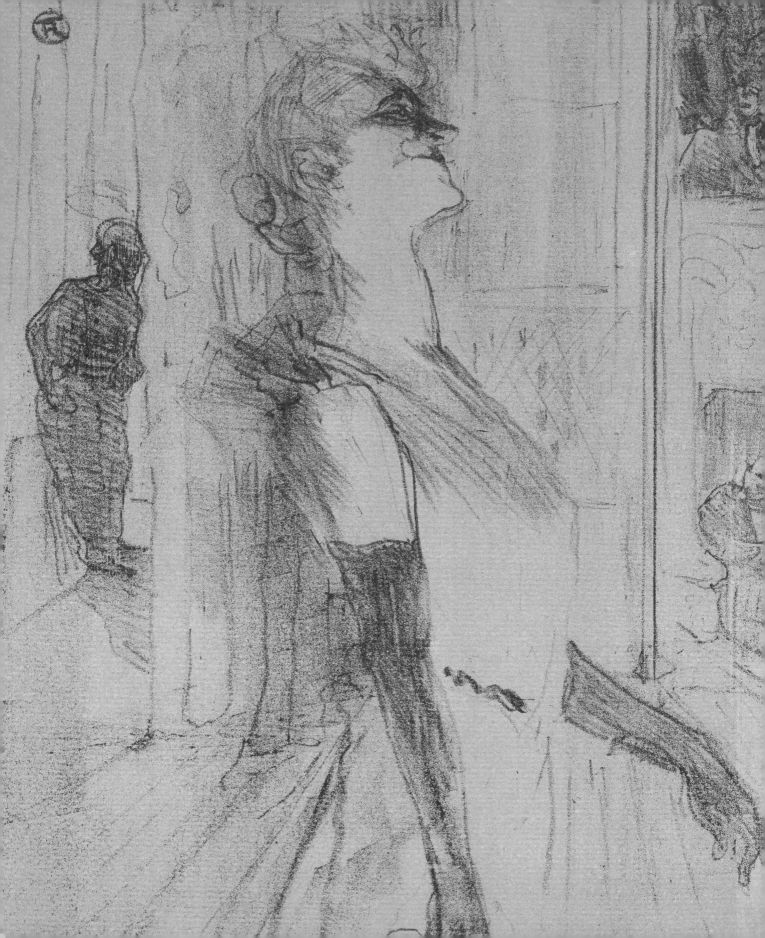

Yvette Guilbert

YVETTE GUILBERT (1865–1944) became one of the most famous cabaret stars of the fin-de-siècle (fig. 11). Her career path reversed the direction of many of her peers in Montmartre, who started out in bohemian nightclubs and later aspired to become serious actresses in the theater. Guilbert went from being a dramatic actress to performing a mixture of song and speech in the café-concerts, where she made her name starting with an appearance at the Eldorado in 1889. She was known for extremes of gesture and emotion in an act that also showcased her wit, along with elements of surprise, contrast, and eccentricity—all qualities familiar to Lautrec's art. One contemporary noted the parallels between the performer and the artist, asserting that "sweetness and ferocity, triviality and refinement, phlegm and exaggeration, share an equal part in their designs."[1]

The two likely met around 1891, when Guilbert was already established as a successful cabaret and café-concert performer. Lautrec may have sought her out, as she later maintained, or she may have approached him in the hope of commissioning a poster, as she had done with the artists Jules Chéret and Théophile-Alexandre Steinlen (fig. 12). Guilbert recognized the importance of graphic artists and even claimed that her signature costume was designed to have "clear lines" like "that of a poster."[2] A major poster never came out of her relationship with Lautrec, but he would add to her fame with numerous other works, including two albums dedicated to the performer.

Guilbert was unfashionably thin and flat-chested, yet she chose low-cut and minimally constructed gowns that emphasized those qualities; the appearance created by these gowns, green in the winter and white in the summer, against her pale skin accentuated by red hair and ever-present long black gloves, became her trademark. This look was so recognizable that Lautrec could include a fragment of Guilbert's figure in the background of his *Divan Japonais* poster and count on audiences to identify the star from her dress and gloves alone (see pl. 12). On the cover of the artist's first *Yvette Guilbert* album, the gloves even stand in for the actress herself (pl. 2).

Guilbert's gift for turning potentially negative features into attractions extended to her stage act. A poor singer with a limited range, she came to excel in a performing style that was part song and part declamation, earning her the description of "diseuse" (speech-singer). Onstage, she eschewed flirtatious pleasantries with the audience for an indifferent manner and coarse language. She played to the taste for the sharp wit and blasé attitude of disreputable Paris, becoming closely associated with the turn of phrase "fin-de-siècle" and the depravity and nihilism it predicted.

Fig. 11. G. Camus (successor of Isidore-Alphonse Chalot, d. 1893), *Yvette Guilbert*, about 1894

M^ELLE YVETTE GUILBERT
CHALOT. PHOT. G. CAMUS Succ^r
PARIS REPRODUCTION INTERDITE 18, Rue Vivienne

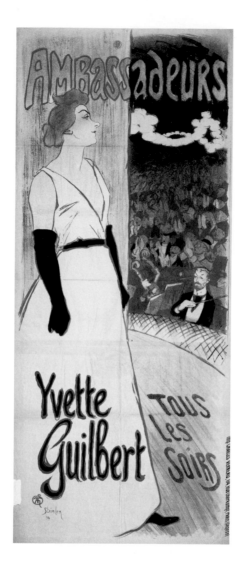

Fig. 12. Théophile-Alexandre Steinlen (French, 1859–1923), *Yvette Guilbert at the Ambassadeurs*, 1894

Her costume looked like a shroud to some, and her songs were vulgar. She was known as "a master of the art of declaiming harmless obscenities in a nonchalant manner."[3]

Near the beginning of her collaboration with Lautrec, Guilbert rejected a poster design, possibly because it was unflattering. Later, she would prove willing to allow and even encourage Lautrec's biting representations. One observer remarked that she must have been "blinded by her greed for publicity" to have accepted these portrayals.[4] Whatever her motivations, Guilbert appreciated the potency of playing with expectations, particularly in the realm of publicity. Works by other artists and photographers in her circle tend to show her in a more conventionally attractive guise, looking younger and gentler than in Lautrec's work. His images of Guilbert, which shed a harsher, more caricatural light on her face and figure, are infinitely more memorable, revealing her deep range of expression and command of her audience.

This is especially evident in Lautrec's first album dedicated to Guilbert. Variety of expression was integral to her act, and the album's many images, combined with text by Gustave Geffroy, traverse the many facets of her act, by turns shocking or pleasing, disturbing or delightful, and convey its intense effects. In one of the album's most acute illustrations, every element of her body communicates emotion, from the droop of her eyelids, to her sharply defined cheekbones, to her fingers gripping the curtain (pl. 6). The related drawing portrays Guilbert as at once fascinating and repelling, almost clown-like with her makeup and gaunt features, while also deeply sympathetic (fig. 13).

A critic at the time recorded the album's invitation to the viewer: "Watch this shadowy form freeze into expressive grimaces. . . . Watch as the ugly lines of disgust, the great happy laugh, the impudent pout, the terrible lassitude follow one upon the other. . . . The shadows that are too harsh and the light that is too lurid bring out the sharp forms of this strange skeleton, and the stiff ghost is as moving as an apocalyptic vision."[5] — H B

Fig. 13. *Yvette Guilbert Taking a Curtain Call*, 1894

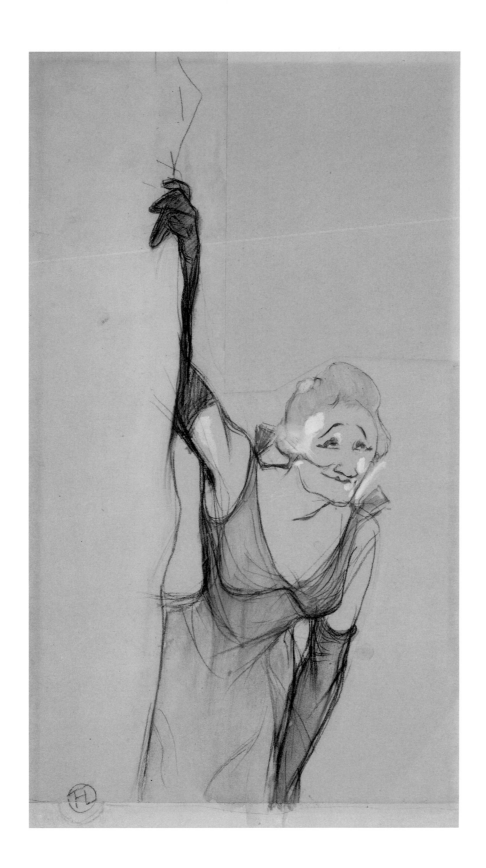

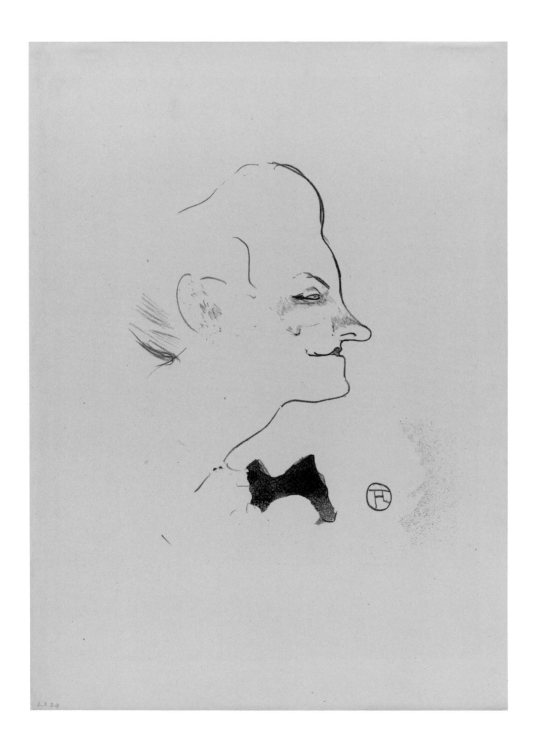

1

Yvette Guilbert, from the
portfolio *The Café-Concert*
1893

2

Cover
From the first *Yvette
Guilbert* album
1894

This luxury publication was
a commercial and critical
success, called "the apotheosis
of the diva" by one reviewer.
Guilbert hand-signed each
album. For the cover design,
Lautrec focuses on Guilbert's
trademark black gloves and a
feather fan.

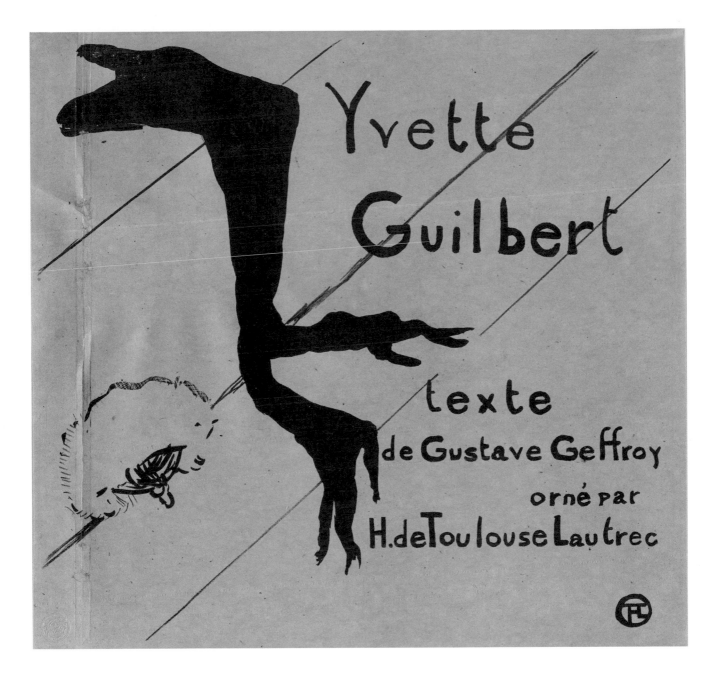

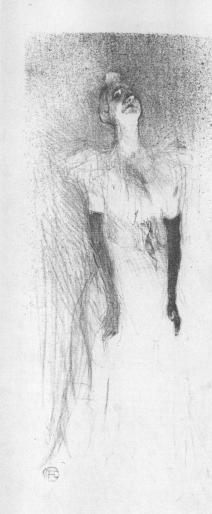

C'est affreux, blessant, et vous, Monsieur, ou Madame, vous vous lèverez, quitterez votre siège, fuirez ce lieu empesté, déclarerez sur le seuil que jamais plus vous ne reviendrez respirer cette atmosphère, entendre ces cris, assister à ce scandale.

Il est certain que la répulsion peut être vive, que l'esprit peut gagner là un malaise, un effroi, un dégoût, une sorte de courbature morale dont il sera quelque temps à se défaire. Et même, il se peut concevoir un sentiment moins vif, moins horrifié, moins agressif, qui rejette néanmoins ceux qui auraient tenté la fâcheuse expérience à leurs passe-temps acceptés, musiquettes convenues, plates comédies, ordinaires vaudevilles, tels que l'on peut en trouver dans les théâtres les mieux tenus. Au moins, un décorum est conservé, les femmes rient derrière l'éventail et les hommes ne fument pas à l'orchestre. Mais avouez que l'intellectualité du plaisir admis n'est pas toujours sensiblement supérieure. Et avouez aussi que la déclaration contre le café-concert, si elle est quelquefois, chez quelques-uns, sincère, peut se trouver aussi, chez un grand nombre, hypocrite. Il y a des faits et il y a des présomptions.

Les faits, c'est que le public des cafés-concerts, de certains tout au moins, varie avec les jours, et finit par résumer assez bien les différents états des couches sociales. Il y a même une saison de l'année, de Juillet à Septembre, où le public habituel est presque totalement remplacé. C'est l'époque des concerts en plein air, dans les verdures, sous les astres. La scène est installée, cette fois, assez loin des faubourgs, et si quelques fidèles émigrent, si les étrangers affluent, il n'est pas interdit de croire que nombre de spectateurs des théâtres d'hiver changent de distraction avec l'été. Comme on chante les mêmes choses sous le ciel étoilé que sous les quinquets, c'est donc l'atmosphère matérielle qui était, pour beaucoup, l'objection, et non l'atmosphère morale.

La vérité, c'est qu'il n'y a pas, dans une grande ville telle que Paris, de si grandes différences de public. Ou plutôt, la grande différence crée une infime minorité et une immense majorité. Et il y a ceux qui restent chez eux, qui

3

Third plate

1894

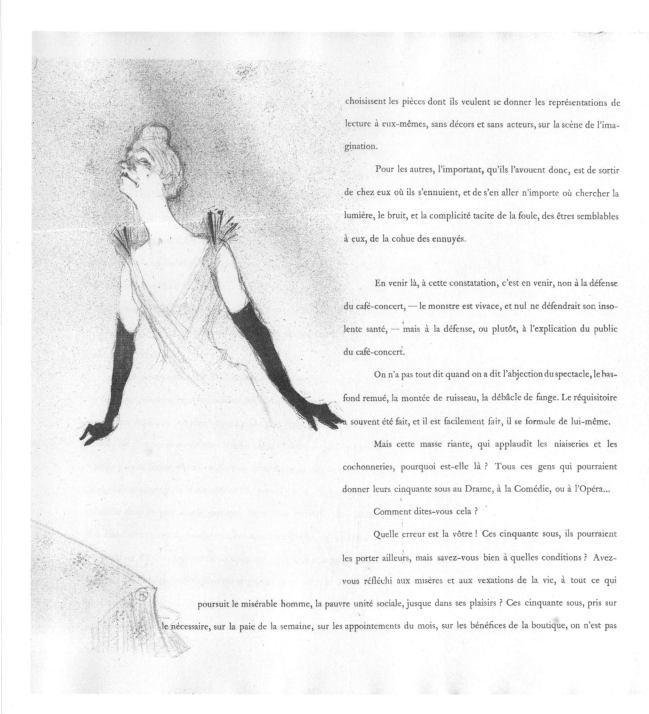

choisissent les pièces dont ils veulent se donner les représentations de lecture à eux-mêmes, sans décors et sans acteurs, sur la scène de l'imagination.

Pour les autres, l'important, qu'ils l'avouent donc, est de sortir de chez eux où ils s'ennuient, et de s'en aller n'importe où chercher la lumière, le bruit, et la complicité tacite de la foule, des êtres semblables à eux, de la cohue des ennuyés.

En venir là, à cette constatation, c'est en venir, non à la défense du café-concert, — le monstre est vivace, et nul ne défendrait son insolente santé, — mais à la défense, ou plutôt, à l'explication du public du café-concert.

On n'a pas tout dit quand on a dit l'abjection du spectacle, le bas-fond remué, la montée de ruisseau, la débâcle de fange. Le réquisitoire a souvent été fait, et il est facilement fait, il se formule de lui-même.

Mais cette masse riante, qui applaudit les niaiseries et les cochonneries, pourquoi est-elle là ? Tous ces gens qui pourraient donner leurs cinquante sous au Drame, à la Comédie, ou à l'Opéra...

Comment dites-vous cela ?

Quelle erreur est la vôtre ! Ces cinquante sous, ils pourraient les porter ailleurs, mais savez-vous bien à quelles conditions ? Avez-vous réfléchi aux misères et aux vexations de la vie, à tout ce qui poursuit le misérable homme, la pauvre unité sociale, jusque dans ses plaisirs ? Ces cinquante sous, pris sur le nécessaire, sur la paie de la semaine, sur les appointements du mois, sur les bénéfices de la boutique, on n'est pas

4

Fourth plate
1894

7

Frontispiece
From the second *Yvette Guilbert* album
1898

This album is known as the English Series because it was published by the British firm Bliss, Sands & Co. The images of Guilbert it contains are relatively gentle, and the album on the whole is more commercial in feel. Most of the plates share titles with songs in her repertoire.

8

Fallen for It
From the second *Yvette Guilbert* album
1898

Dramatic stage lighting flattens Guilbert's figure and heightens the angles of her features.

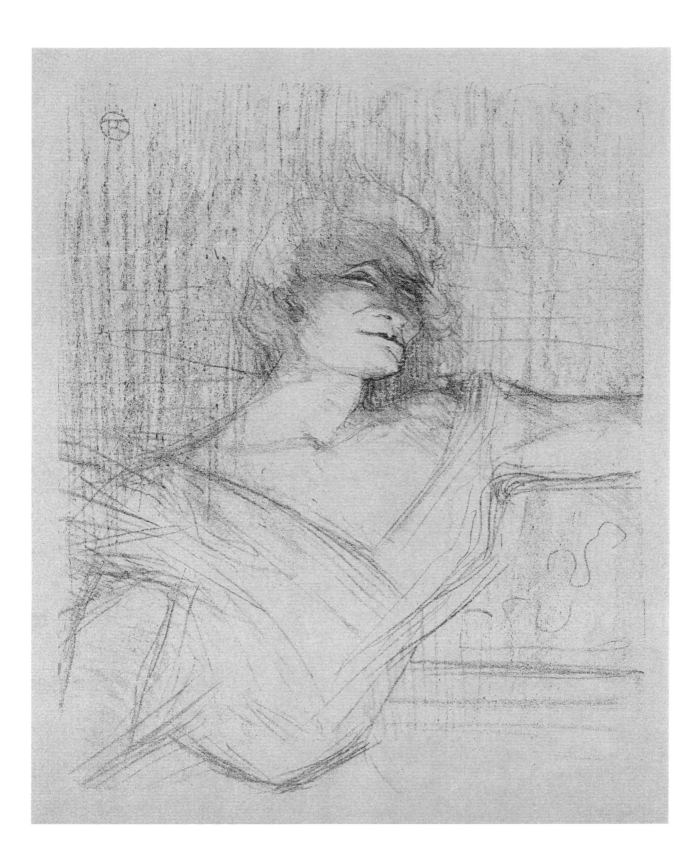

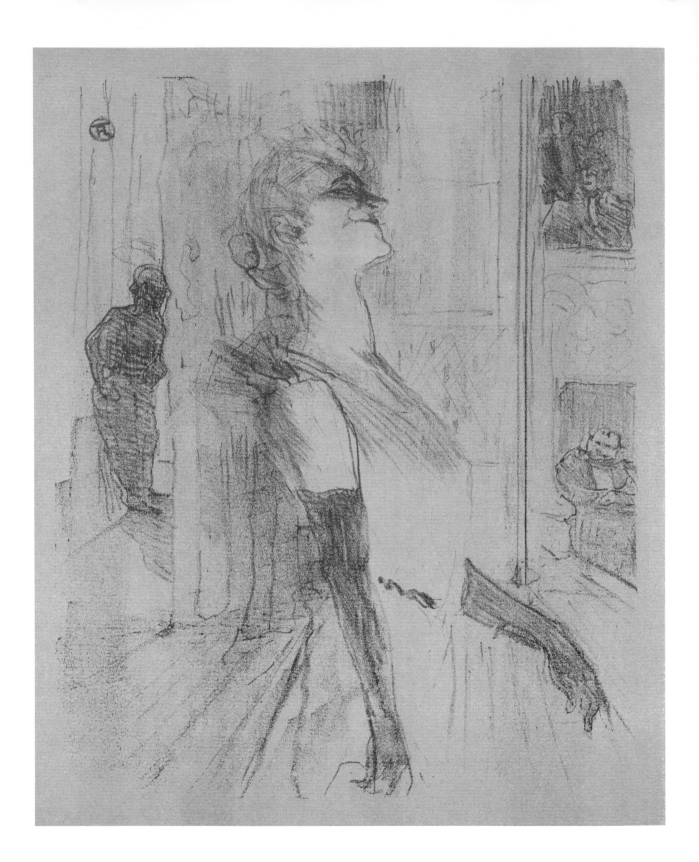

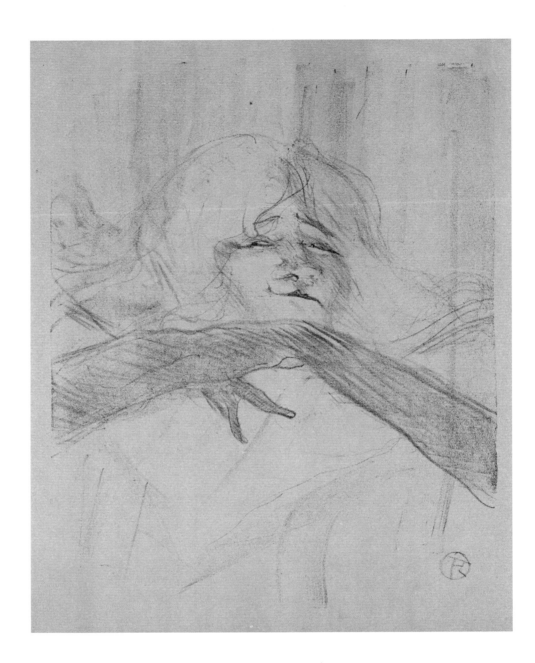

9

On Stage
From the second *Yvette*
Guilbert **album**
1898

10

Linger, Longer, Loo
From the second *Yvette*
Guilbert **album**
1898

Guilbert's saucy expression
melts into her black gloves,
which stretch across the
picture plane with tentacle-
like fingers.

11

Greeting the Public
From the second *Yvette Guilbert* album
1898

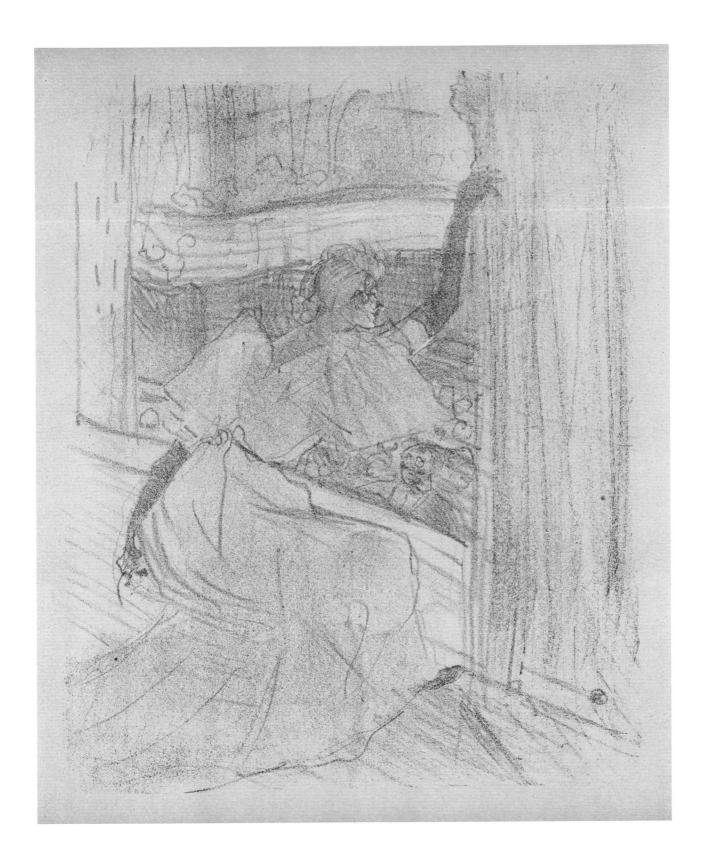

Jane Avril

IN HER MEMOIRS, Jane Avril (1868–1943) wrote of Toulouse-Lautrec: "I owe him the fame that I enjoyed, dating from his first poster of me."[1] Avril developed her signature dance routine and "look" onstage in Paris, but it was Lautrec who preserved her reputation through posters and prints that are among the most renowned of his oeuvre. These works are some of Lautrec's more varied and enduring impressions of a performer, demonstrating his ability to capture Avril's defining qualities even as he portrayed her in a range of roles and costumes.

Lautrec and Avril likely met at the Moulin Rouge in the early 1890s, when Lautrec was a regular customer. Avril was developing an act that incorporated sometimes wild and unexpected movements, which earned her the nickname "Mélinite," after a brand of explosives (fig. 14). While over the course of her career she appeared at the Jardin de Paris, the Folies-Bergères, the Casino de Paris, and the Théatre de l'Oeuvre, it was at the Moulin Rouge that she became famous. However, Lautrec first portrays her in a poster not as a performer but as a spectator at the Orientalist nightclub known as the Divan Japonais, or "Japanese sofa" (pl. 12). She is nonetheless the star of the scene, identifiable by her bright red hair, lithe physique, and even the extreme size and decoration of her hat—all of which contributed to her electrifying effect as a dancer. One writer commenting on Avril's appearance in this poster noted "how stylish she is, this exquisite creature, nervous and neurotic."[2]

The peculiar contortions of Avril's performance, with limbs extended in all directions and feet askew, were reminiscent of the appearance of female patients diagnosed with "hysterical" disorders by Jean-Martin Charcot, a teacher of Sigmund Freud and the leading neurologist at the Salpêtrière hospital in Paris (fig. 15). Avril, who suffered from a medical condition known as chorea, characterized by

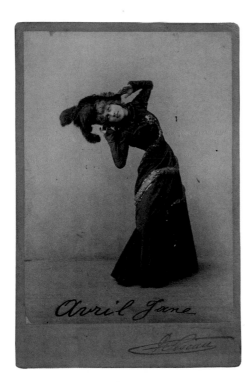

Fig. 14. Paul Sescau (French, 1858–1926), *Jane Avril*, about 1892

Fig. 15. Albert Londe (French, 1858–1917), *Catalepsy*, from *Iconographie photographique de la Salpêtrière*, 1879–80

episodes of abrupt and involuntary movements, had spent time under Charcot's care. Despite this condition, Avril's dances onstage were deliberately and consistently performed, with a subtlety that was noted by admirers. She seems to have drawn purposefully on her history of neurological illness to create a unique style of movement. Setting her feet at odd angles, for example, as seen in posters for the nightclub Jardin de Paris (pl. 16) and for a dance troupe (pl. 19), distinguished her from other dancers. These unconventional traits might have signaled neurosis to some onlookers, as did her unfashionably thin frame, but they also added to her allure.

Lautrec's depictions of Avril speak to his regard for her as a talented dancer and as a sensitive artist and close friend. His preparatory drawing for a lithograph of her looking carefully at a freshly printed sheet in the workshop of Edward Ancourt, for example, is an exceptionally respectful image (fig. 16). A stylish woman enjoying the latest offering of a printmaking studio was a stock theme of the print revival in the late nineteenth century, and Lautrec's related depiction of Avril was an apt choice for the cover of a new and influential portfolio publication for connoisseurs of color prints (pl. 17). Rarely, however, was the female subject portrayed as so obviously intelligent and discerning.

Much of Avril's biography suggests her canny ability to survive difficult circumstances and even turn them to advantage while shaping her public image. Born Jeanne Beaudon in the working-class Belleville section in Paris in 1868, she escaped an abusive and financially unstable childhood only to land in the confines of the Salpêtrière hospital in the early 1880s. It may have been there that she discovered her talent for dance, when she participated in the tradition of the "ball of the crazies," an event where mentally ill patients in costume mingled with the public.[3] After leaving the Salpêtrière, she became a performer, eventually anglicizing her first name to Jane and adding a surname more suitable to the stage. This new name played to the vogue for all things English, which she further indulged by giving English titles to the pieces included in her 1894 songbook *Repertoire de Jane Avril*, with a cover adapted from Lautrec's lithograph of her for the portfolio *The Café-Concert* (pl. 18). She also spent time in London with the dance troupe of a better-known performer who went by Mademoiselle Eglantine, a name that reflects the corresponding English vogue for French entertainment (pl. 19). As her career developed, Avril chose roles (including Anitra in *Peer Gynt*) and costumes that reinforced her reputation as a deviant temptress (figure 14, pl. 20).

The writer Arsène Alexandre astutely summarized the remarkable affinity between Jane Avril and the artist who ensured her legacy: "Equal measures of instinct and will make up Mélinite's art, and I suppose that's how her art finally came to meet that of Lautrec, which is also very spontaneous in its execution, yet very calculated in its conception. Painter and model, together, have created a true art of our time, one through movement, one through representation."[4] — HB

Fig. 16. *Jane Avril Looking at a Proof*, 1893

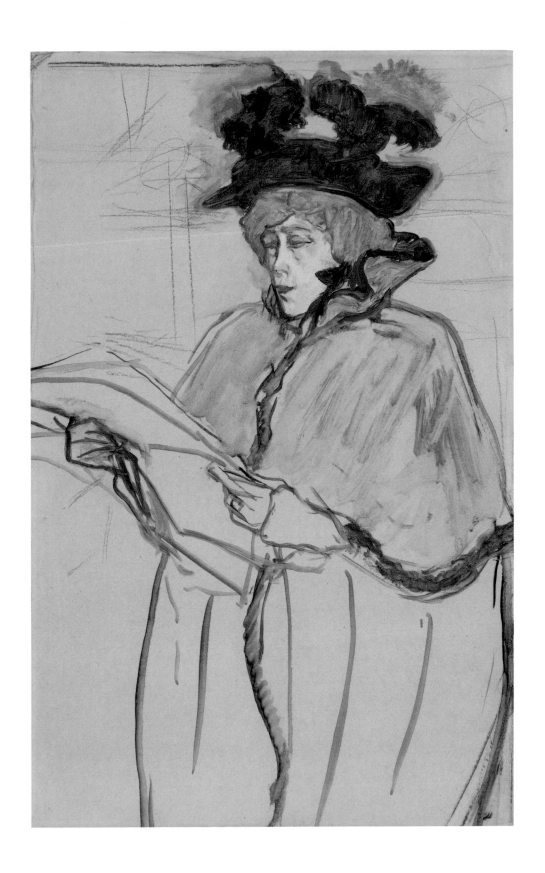

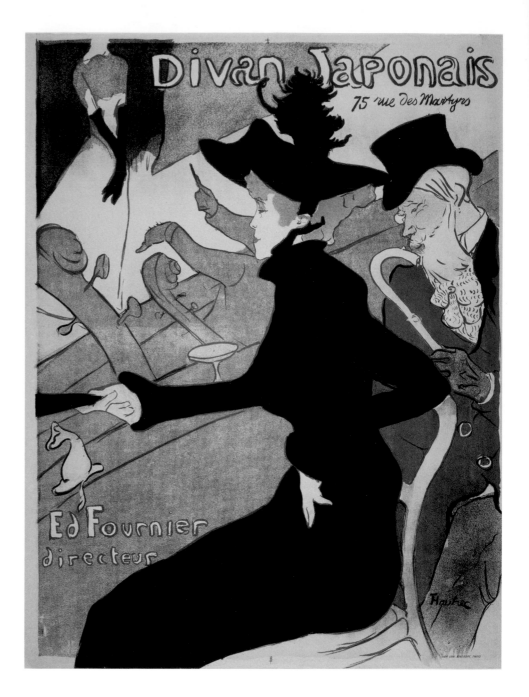

12

Divan Japonais

1893

Avril is watching a performance
by Yvette Guilbert (recognizable
by her black gloves), while
accompanied by the dandy
and writer Édouard Dujardin.
She holds a fan in one hand;
the little pouch on the rail is
her purse, set above the name
of the nightclub director:
Ed (Édouard) Fournier.

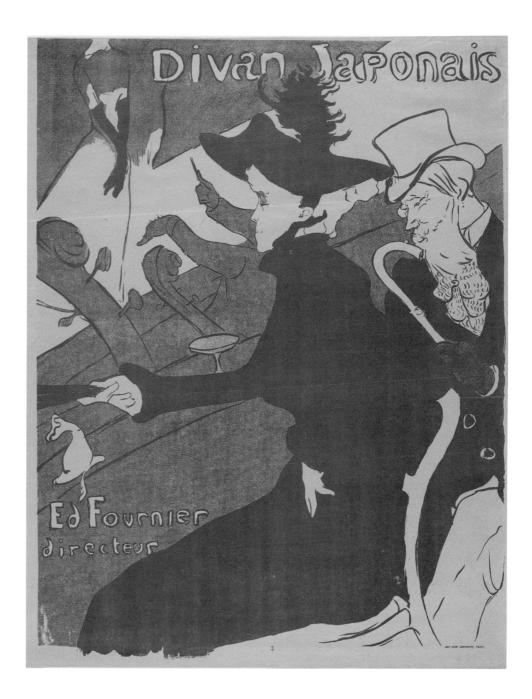

13

Divan Japonais

1893

This and the following two
images are proofs created
while making the poster, before
it was printed in multiple
copies and distributed. The
olive-green image provides
the overall design of the poster.

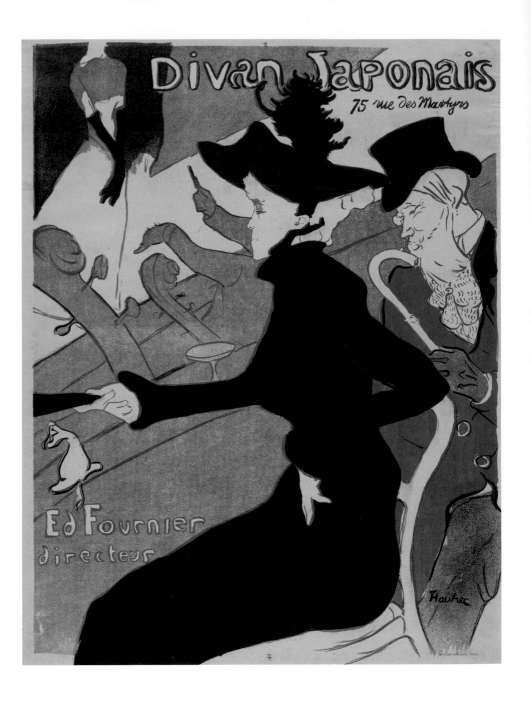

14

Divan Japonais

1893

Color lithography uses multiple
stones to print the colors. Here
black is printed over the green,
testing how accurately the two
stones register when printed
together on one piece of paper.

15

Divan Japonais

1893

This proof shows red and
orange, bright colors that define
and highlight key areas.

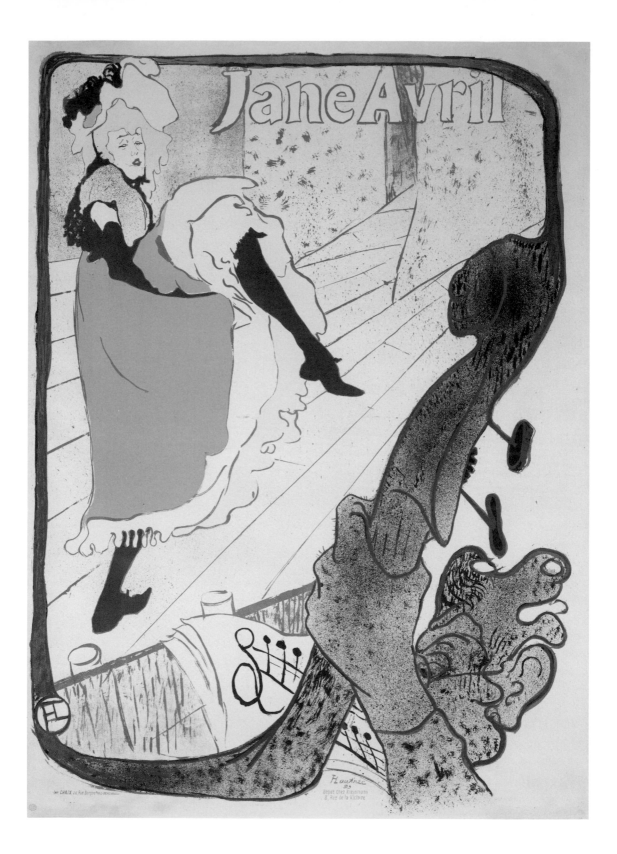

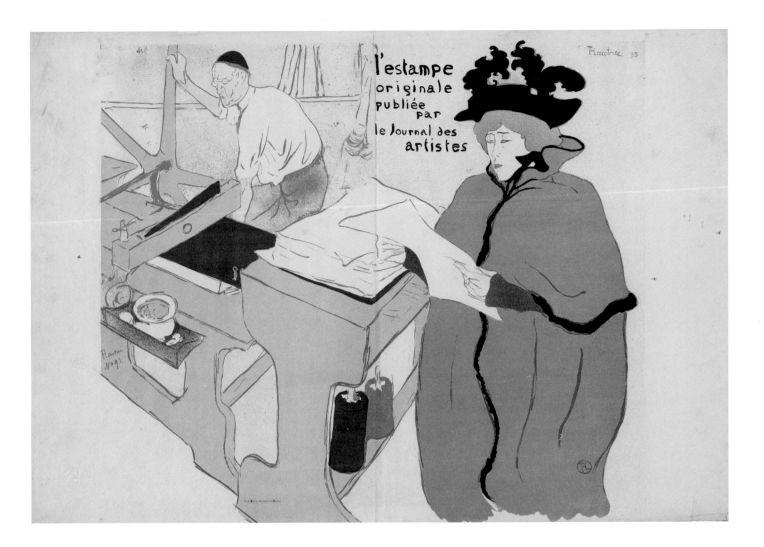

16

Jane Avril (Jardin de Paris)

1893

Avril's dances were a highlight
of evenings at the Jardin de
Paris, an enormously popular
club that opened in 1885
on the Champs-Élysées.
Avril commissioned this poster
from Lautrec, who suggestively
pairs her pose of a high kick
with the upright neck of a
double bass.

17

Cover of the portfolio
The Original Print
(L'Estampe Originale)

1893

Avril appears here as a
connoisseur of prints. In the
background, the elderly
master printer Cotelle turns
the star-shaped wheel of a
Brisset press at Ancourt's
studio, presumably at work
on the portfolio.

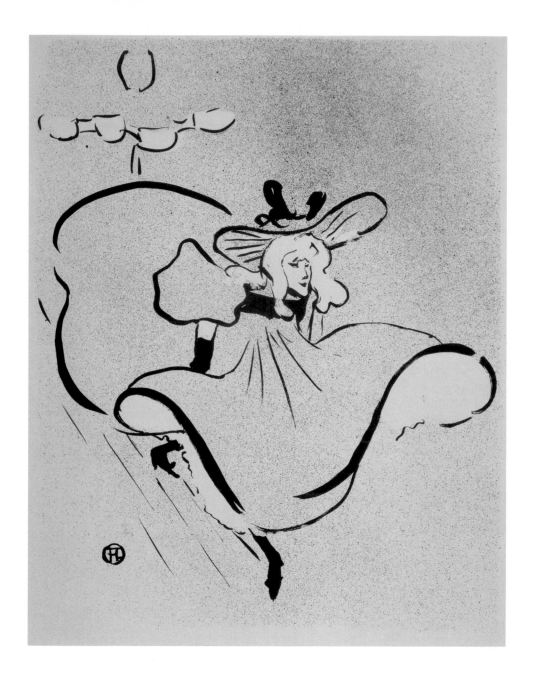

18

Jane Avril, from the portfolio
The Café-Concert
1893

This pithy image of Avril condenses the essence of her quirky stage presence into swooping, expressive calligraphic lines. It is the first of eleven lithographs by Toulouse-Lautrec in the groundbreaking portfolio *The Café-Concert*, a limited-edition compendium of portraits of the stars of Paris nightlife.

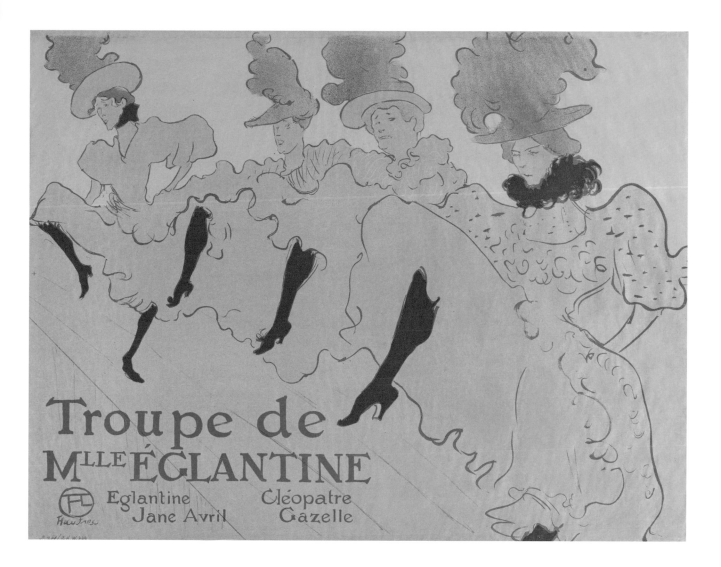

19

Mademoiselle Églantine's Troupe

1896

Avril commissioned this poster
in a letter addressing Lautrec
as "Mon cher ami" (My dear
friend) from London in January
1896. She appears at the far
left of the poster, asserting her
own unruly style in contrast to
the three other dancers, led
by Mademoiselle Églantine on
the far right.

20

Jane Avril

1899

This poster is Lautrec's last
depiction of Jane Avril, as well
as one of his most recognizable
images. It is probably based
on a publicity photograph (see
fig. 14). The snake in the lower
left of the composition is an
extra element that appears only
on early versions of the poster.

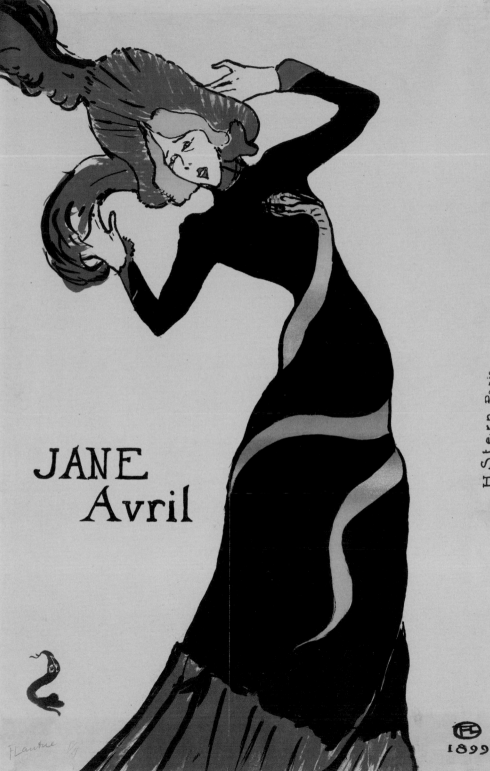

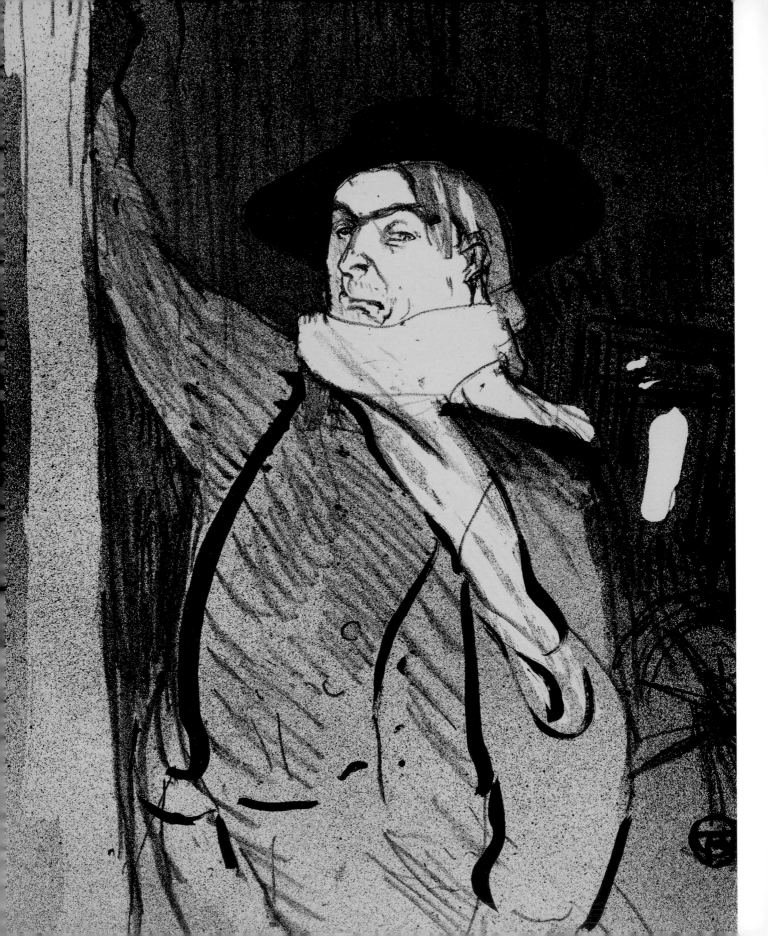

Aristide Bruant

IN THE PANTHEON OF STARS whom Lautrec depicted, the *chansonnier* Aristide Bruant (1851–1925) stands apart (fig. 17). He was the only male performer with whom Lautrec had a long successful relationship, and he was also the most adept at self-promotion and marketing. Bruant's self-fashioning and Lautrec's brilliant artistic abilities were perfectly suited to the medium of the color poster; combined, they produced some of the most revolutionary and iconic images of fin-de-siècle Paris.[1]

Lautrec and Bruant shared a number of attributes: both displayed a remarkable talent for image-making and a keen understanding of celebrity and performance. They were also adept at exploiting the frisson between high and low, artifice and reality. The artist's powerful lithographs of Bruant amplified this unique and savvy performer while skillfully masking their own contradictions: marketing a man who became rich by impersonating the poor; appearing spontaneous and unproduced, when in fact they were carefully studied and executed; and masquerading as insightful portraits while functioning as highly effective commercial advertising tools.

Bruant first made his name performing at the Chat Noir, a cabaret that was the haunt of artists, poets, writers, and other denizens of Montmartre. Soon Bruant founded his own café, Le Mirliton, where he performed songs he wrote about the lives of pimps, thieves, prostitutes, and thugs who eked out a living on the margins of the great city. Although Bruant himself was from a bourgeois background, he assumed the persona of an outsider, adopting the colorful slang of the lower classes and dressing in a simple costume often topped with a black cloak, red muffler, and wide-brimmed hat.[2] He hurled insults at the patrons of his café, a tactic that proved surprisingly popular with his audience and furthered his

authenticity as a dispossessed poet railing against the injustices of life. His bellicose manner, poignant and original songs, and personal charisma made him a star not just in Montmartre but also across Paris and throughout Europe. By 1892, the year of Lautrec's first poster of Bruant, the performer was already a wealthy man. Yet he maintained his carefully honed pose as an outsider, parlaying his raffish persona into invitations to perform at the upscale Ambassadeurs and Eldorado café-concerts in the heart of Paris.

To market this audacious performer, Lautrec seized upon the most salient aspects of Bruant's costume and appearance. What sets Lautrec above his fellow artists, however, is his ability to create images that transcend the mundane and enter the realm of the symbolic, rather than relying on a mere photographic likeness (fig. 18). He began by making detailed

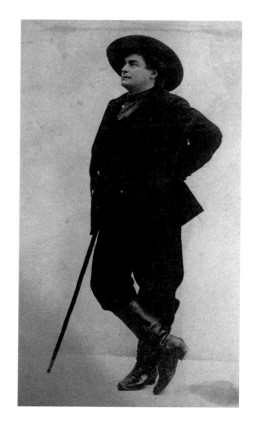

21

**Ambassadeurs: Aristide Bruant
in His Cabaret**

1892

Lautrec's first poster for
this performer was a robust
summation of the Bruant brand,
capturing Bruant's unique
costume of black felt hat, red
muffler, and sweeping overcoat.
In the background, a shadowy
figure represents the hoodlums
who populated the songs of
Bruant. The poster was widely
distributed throughout Paris in
the summer of 1892. Its bold
design, as well as its ubiquity,
greatly furthered the reputation
of both Bruant and Lautrec.

22

**Eldorado: Aristide Bruant
in His Cabaret**

1892

In his second poster for the
performer, Lautrec reused the
design of the Ambassadeurs
poster, rendering it in a mirror
image. This is the first poster in
which the artist's monogram—
the initials *HTL*, enclosed in
a circle—is incorporated into
the design. This feature would
appear in all his subsequent
posters and serve as a logo for
the artist, forever linking him to
the performers depicted.

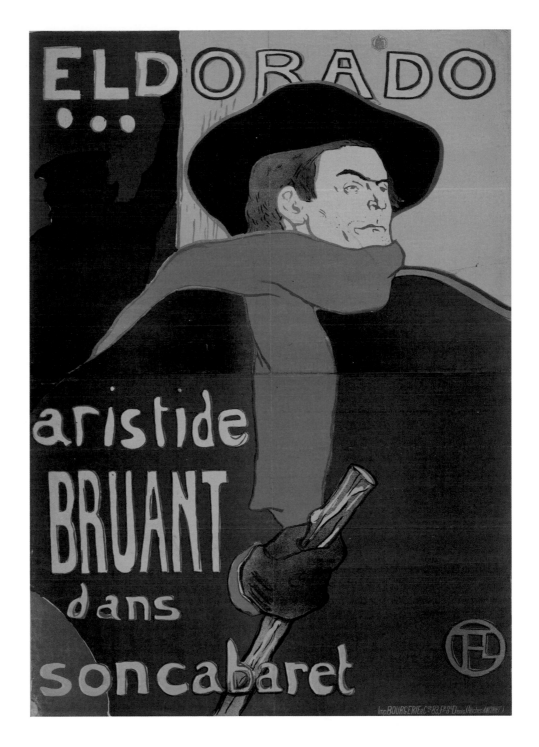

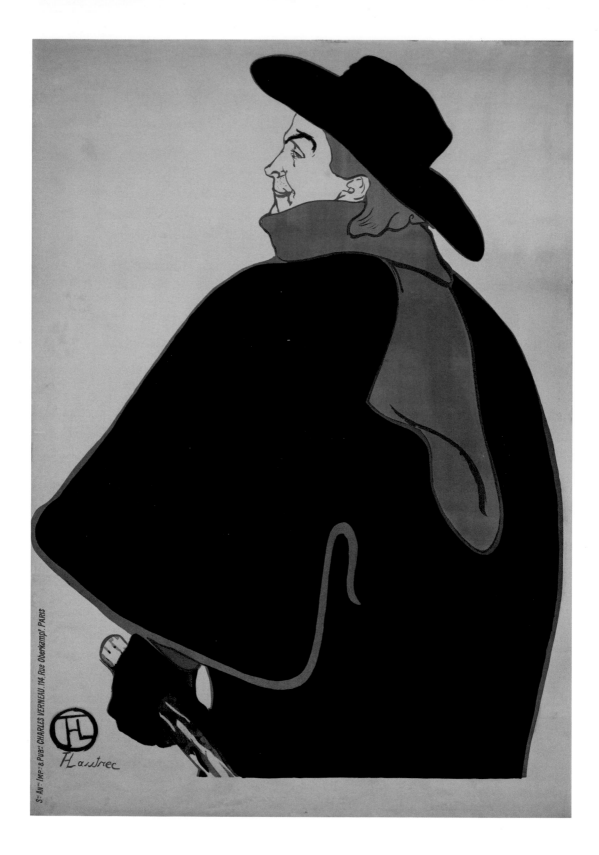

23

Aristide Bruant in His Cabaret
1893

This iconic image is among Lautrec's most successful poster designs. By eliminating background and anecdotal detail, he created a timeless image of the performer, reduced to his signature hat, muffler, and cloak. The bold and simple design ensured that it would stand out when pasted to the walls and kiosks across Paris, and lent itself to renderings in other formats, including the glass lamps that hung outside Bruant's cabaret.

24

Aristide Bruant in His Cabaret
1893

The second state of the poster features hand-lettering. Although carefully planned by the artist, the willfully irregular text lends an appearance of spontaneity to the image and accords with Bruant's image as an authentic and rough-edged artist.

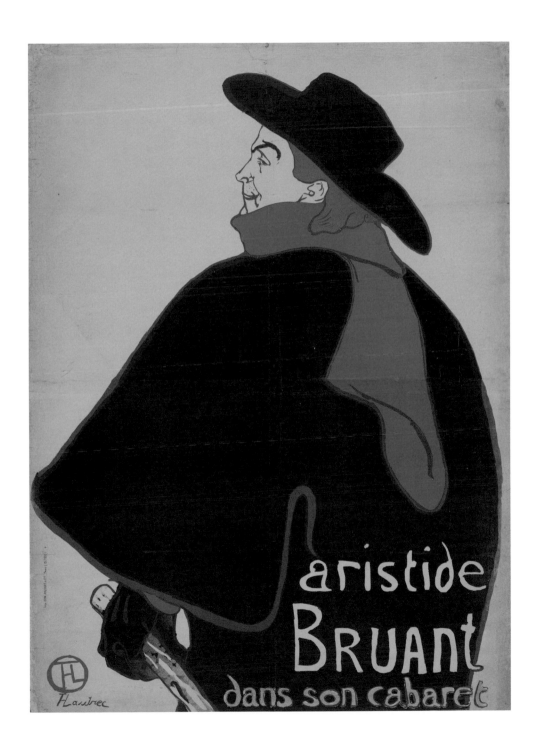

25

Aristide Bruant

1893

Together with Henri-Gabriel Ibels, Lautrec produced eleven lithographs of performers for *The Café-Concert*, a suite of twenty-two prints. Here he places the performer in a pose similar to that of the shadowy figure seen in the background of the Ambassadeurs and Eldorado posters. The monochromatic print is composed of a rich range of mark-making, from the quick scribbles of the lithographic crayon to a more elegant, calligraphic line created by brush and ink.

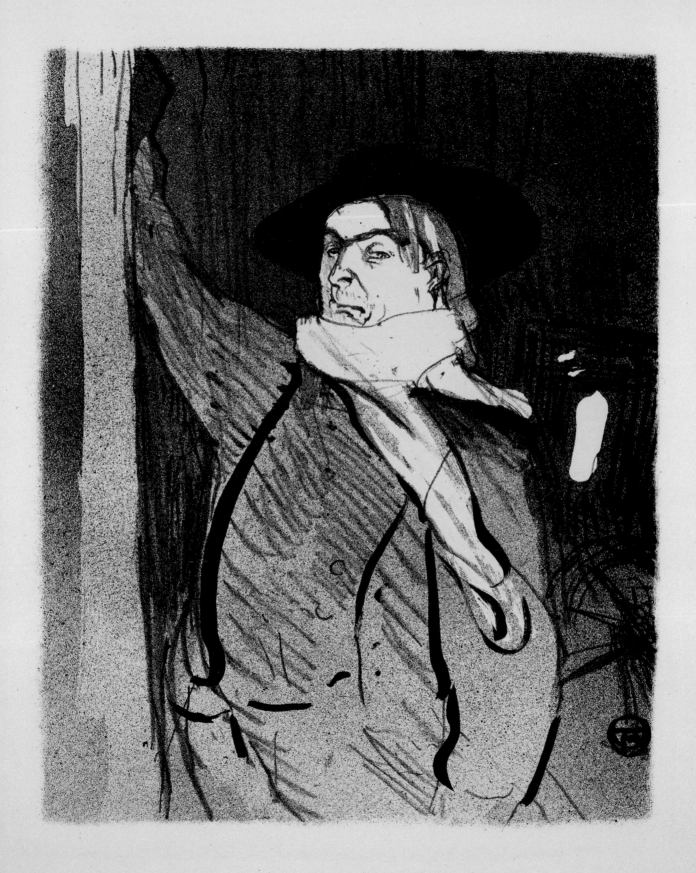

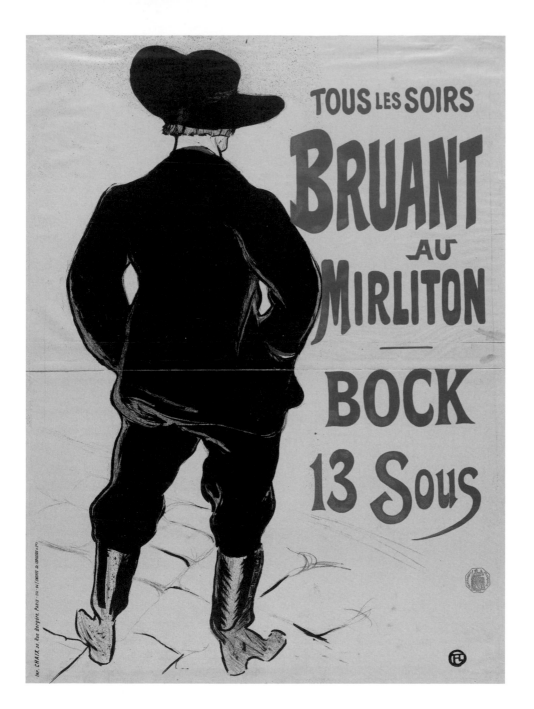

26

Aristide Bruant (Bruant at the Mirliton)
1893

By the time Lautrec created his fourth poster for the performer, he could depict him from the back, knowing that Bruant's costume and confident stance would be recognizable to all. In contrast to *Aristide Bruant in His Cabaret*, here Lautrec works in a more illustrative style, including paving stones to suggest Bruant's credibility as a chansonnier of the street. Bruant's cabaret, Le Mirliton (The Reed Pipe), also published an eponymous journal (see fig. 19)

27

Aristide Bruant (The Second Volume by Bruant)
1893

Lautrec adapted his poster design to advertise the publication of a volume of Bruant's songs and monologues, with illustrations by his fellow Montmartre artist Théophile-Alexandre Steinlen. Bruant's provocative performance style and use of the language of the lower classes earned him a reputation as one of the most celebrated proponents of the *chanson réaliste*, roughly "realistic song." He also published dictionaries of contemporary slang to help listeners decipher his lyrics.

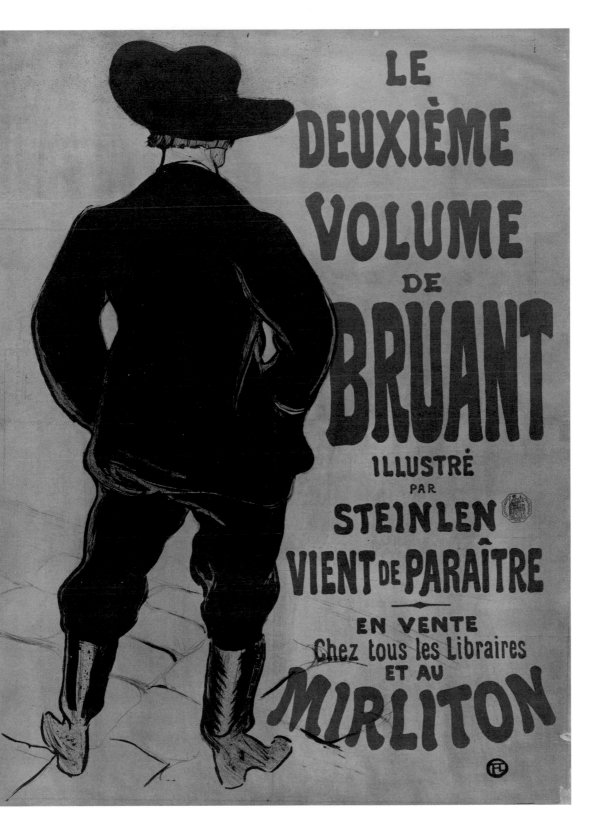

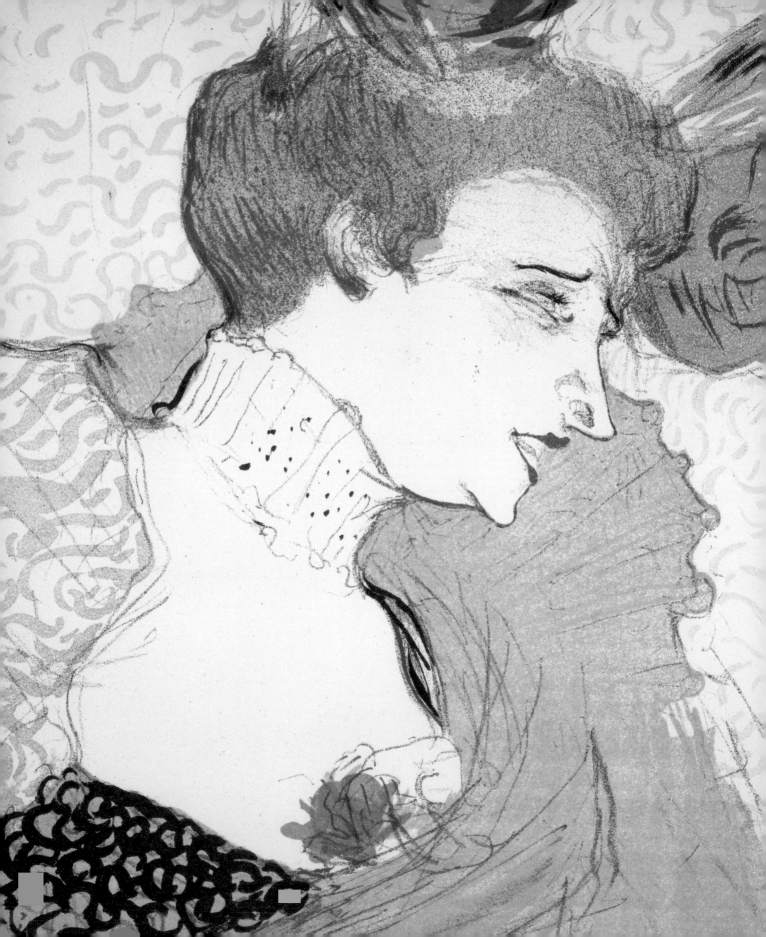

Marcelle Lender

MARCELLE LENDER (the stage name of Anne-Marie Marcelle Bastien, 1862–1926) was one of the most beloved stars of *opéra bouffe*, a type of light opera that flourished in Paris from the mid-nineteenth century (fig. 20). Beginning in 1889, Lender performed regularly at the Théâtre des Variétés in Montmartre, where she specialized in roles featuring pantomime and dance. She first caught Lautrec's attention in 1893, the year he began to attend theater performances with his friend Romain Coolus. That year, he depicted Lender in three lithographs (pls. 28–31), two of which were published by *L'escarmouche*, an illustrated literary journal. *At the Variétés* (pls. 28 and 29) features the most daring composition of the three. Albert Brasseur, Lender's costar in the light opera *Madame Satan*, sweeps his arm exuberantly over her head. The lower parts of both figures are nearly obliterated by the glare of the footlights, while their heads are outlined in a shimmering haze of sprayed ink. The impression in green ink includes the text: "Is she fat? Yes! Is she here? Yes yes yes! It's you!" Perhaps Lender is leaning forward to greet the audience as Brasseur gestures toward her, while he or another performer jubilantly announces her entrance.[1]

Lautrec's interest in Lender blossomed into an obsession in 1895, when she performed in a revival of an *opéra bouffe* titled *Chilpéric*. Written by the composer and performer Hervé (Louis Auguste Florimond Ronger), a pioneer of the light opera genre, *Chilpéric* is a comic reimagining of political and romantic intrigue at the court of a medieval French king. The titular king plots to increase his power by marrying Galswinthe, a Spanish princess, and then conspires with his mistress to murder her (although the tale ends happily with the princess saved and the conspirator pardoned). The production was a striking success, running for more than a hundred performances and drawing praise for its lavish set and costume designs.

Lender played the role of Galswinthe, and her performance of a Spanish-style bolero in the second act enchanted Lautrec, who returned at least twenty times to watch her dance. As he told Coolus, who complained about the monotony of these repeated visits, "I come strictly in order to see Lender's back. . . . Look at it carefully; you seldom see anything so magnificent. Lender's back is sumptuous."[2] The artist's friend and biographer Maurice Joyant recalled that Lautrec arrived every evening at the same time and occupied the same chair in order to watch Lender dance.[3]

Unlike Jane Avril or Yvette Guilbert, Lender never became a close friend. Lautrec did, however, convince her to pose in his studio after *Chilpéric* closed, so that he could study

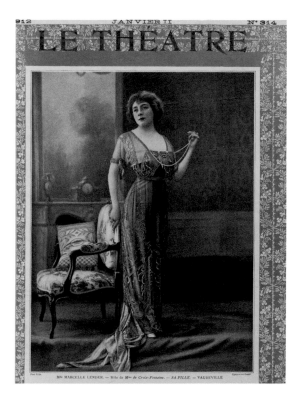

Fig. 20.
"Félix," *Marcelle Lender*, cover of *Le Théâtre*, January 1912

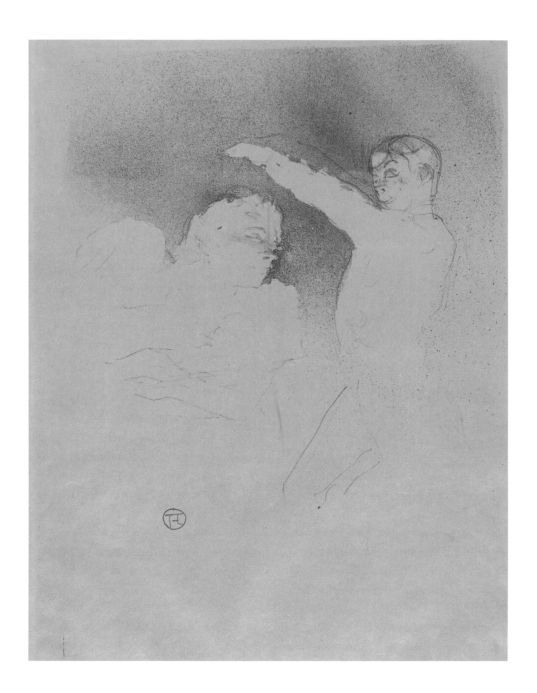

28

**At the Variétés:
Marcelle Lender and
Albert Brasseur**
1893

In two impressions made
in different colors, Lender
appears onstage with Albert
Brasseur, a well-known comic
actor and frequent performer
at the Thêátre des Variétés.
Two years later, Brasseur would
costar with Lender in *Chilpéric*,
playing the title role.

29

**At the Variétés:
Marcelle Lender and
Albert Brasseur**
1893

Est elle grasse?
oui
Est elle ici?
oui oui oui !!!
C'est vous !!!!!!

Nº 4
Lautrec

150

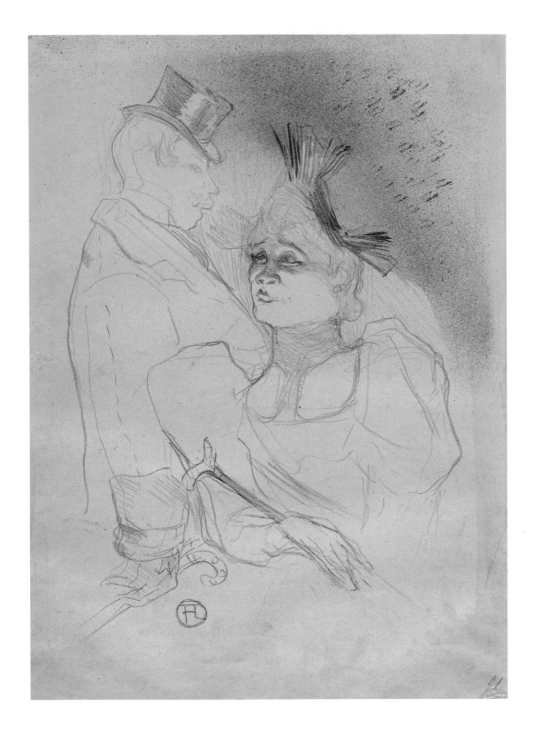

30

**Marcelle Lender and Baron
(Louis Bouchené)**
1893

The profile of a man in a top hat
was a favorite compositional
device of Lautrec's, appearing
most famously in *Moulin
Rouge: La Goulue* (see fig. 4).
Here, Lender's more fully
rendered expression and
flamboyant headpiece allow
her to upstage her fellow actor.

31

**Marcelle Lender in
*Madame Satan***
1893

Madame Satan premiered at
the Théâtre des Variétés in
September 1893, with Lender
and Brasseur in the lead roles.
Lautrec captures Lender's
sumptuous feather fan and
expressive face, lit dramatically
from below by the glare of
footlights.

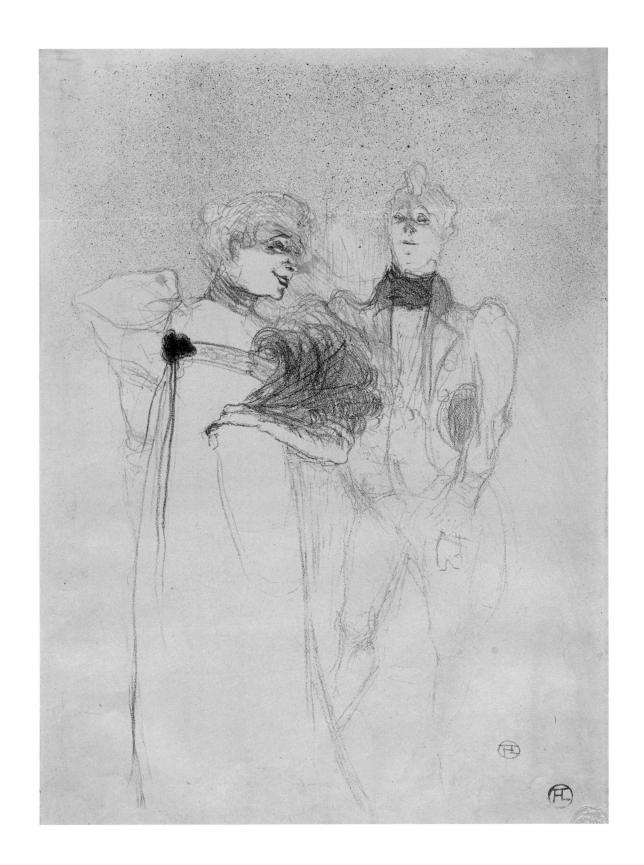

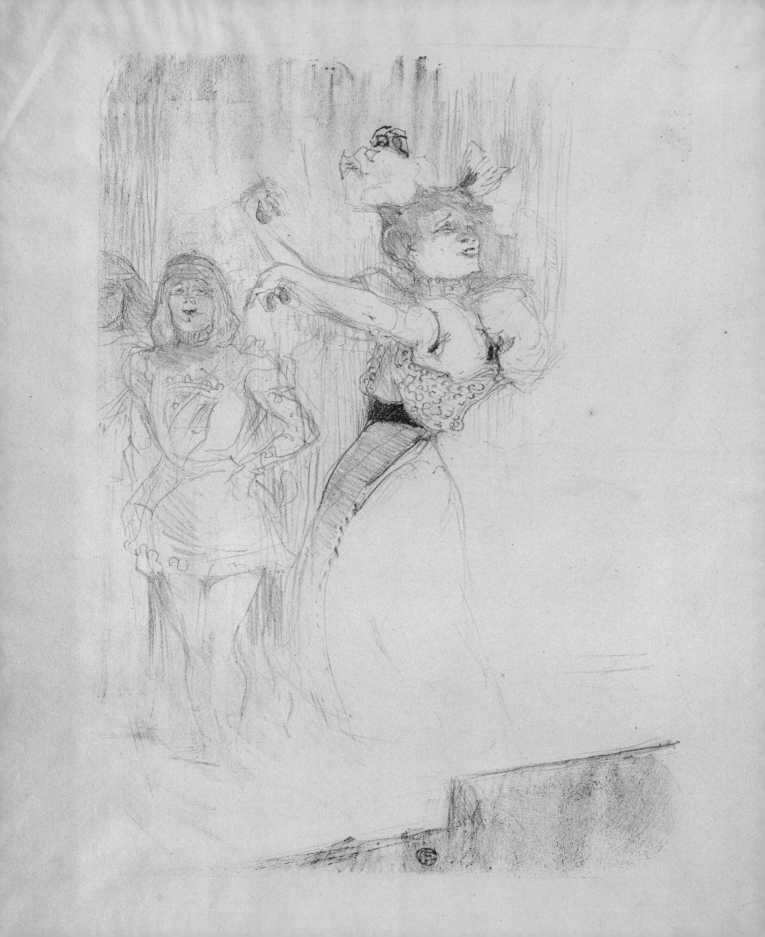

32

Marcelle Lender Dancing the Bolero in *Chilpéric*
1895

These monochrome depictions of Lender dancing her famous bolero are delicate and restrained in comparison to Lautrec's half-length *Marcelle Lender*, with its bold array of colors (pl. 35). Nonetheless, they suggest Lender's spirited stage presence: respectively, her twisting torso, jaunty eyebrows, and elegantly curving back. Unusually for Lautrec, no preparatory drawings for these prints seem to exist, suggesting that he composed the images in a single sitting—which could account for their breezy, spontaneous feel.

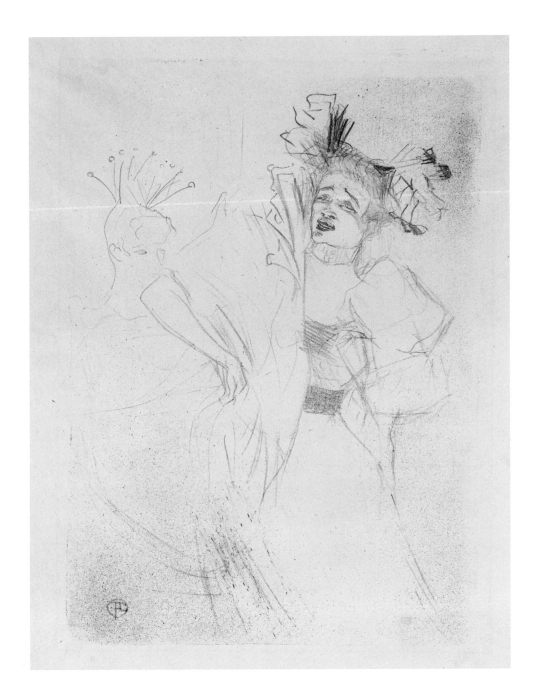

33

Marcelle Lender in *Chilpéric*,
Facing Forward
1895

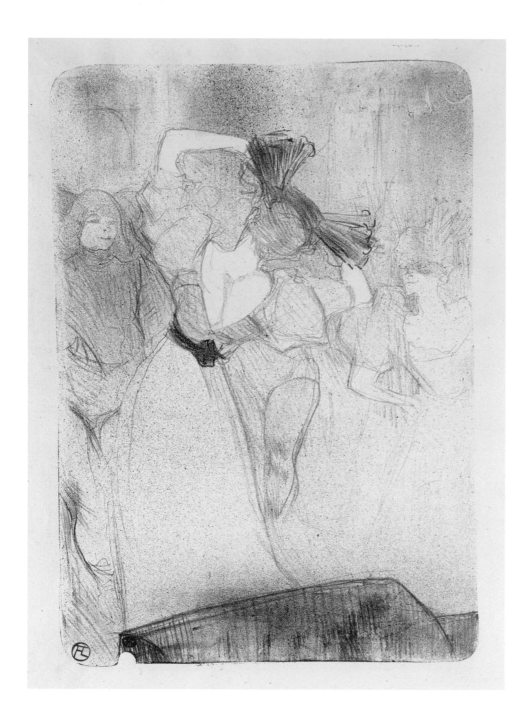

34

Marcelle Lender Dancing the Bolero in *Chilpéric*, **from Behind**
1895

35

Marcelle Lender
1895

Lautrec was invited to publish this work in the German arts magazine *Pan* by its coeditor, Julius Meier-Graefe, who exclaimed about it: "She dances by, in such extravagant makeup, that one no longer knows which is nose and which is eye; only flash of color, tulle, smile, shout, freedom . . . Impressionism!" The editor's colleagues did not share his enthusiasm for Lautrec's "decadent" style and forced Meier-Graefe to resign.

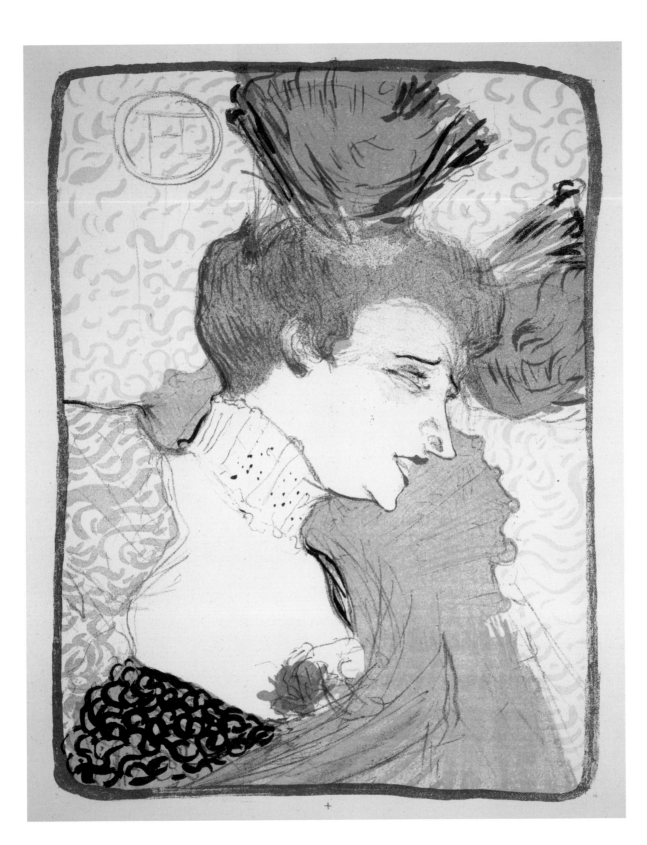

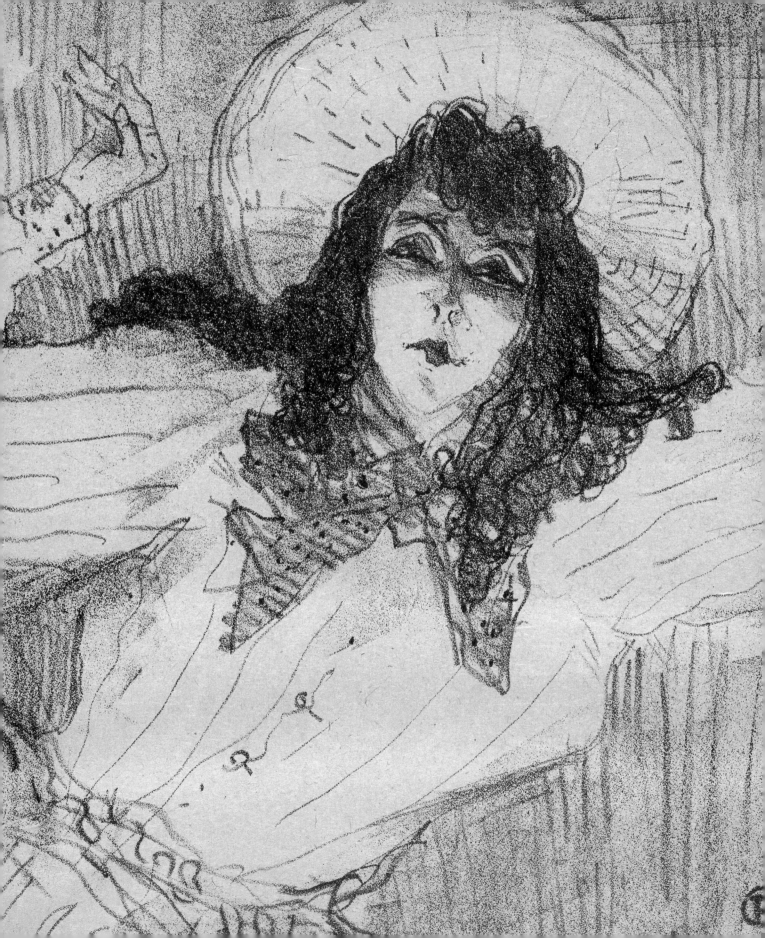

May Belfort

ONSTAGE, MAY BELFORT wore baby-doll costumes as she sang verses loaded with sexual innuendo. One reviewer described her as an "angel of beauty," while less entranced observers noted that she was a "very pretty girl" and a talented dancer with a pleasant voice.[1] In Lautrec's depictions, however, Belfort appears world-weary and haggard. Her face in one particularly unflattering portrait is ghastly white with green undertones, sharply defined angles, and bright pink lips (fig. 23). Lautrec is said to have found Belfort attractive, so it is unlikely that he intended a negative caricature of her; instead, the work eschews convention to get at a deeper reality. His trenchant impressions of her, like many of his portrayals of celebrities, suggest the effects of a demanding life in the spotlight, while also emphasizing a contrast essential to her act — aging debauchery versus youthful innocence.

In 1895, Lautrec saw Belfort at the Cabaret des Décadents, near his apartment in Montmartre. She "lit him up," in the words of a biographer, sparking his desire to capture the qualities of her performance in his art.[2] At the Décadents — and at other venues including

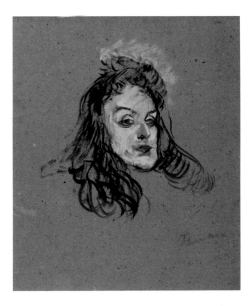

Fig. 23. *May Belfort*, 1895

the Eden-Concert, the Jardin de Paris, and the Parisiana — Belfort wore frocks in yellow or rose with puffy sleeves, and a floppy mob cap over long curls, resembling a child in a Kate Greenaway book. The reference to Victorian England was intentional. Belfort, whose original name was May Egan, was Irish by birth and had worked in London; her repertoire included Irish and English songs as well as American minstrel songs.

Like Jane Avril, Belfort profited from the French fascination with British culture, thought to be decadent and eccentric. The fad for English singers and dancers encompassed other performers represented by Lautrec: Miss Cécy Loftus, Miss Anna Held, and Miss Ida Heath (all called "Miss" in French, rather than "Mademoiselle"). The English in turn considered France to be a more permissive culture. This back-and-forth may explain why performers like May Belfort and Jane Avril adopted stage names that combined an English-sounding first name with a French-sounding last name, to be seen as exotic by either audience.

The sexy-little-girl act was a standard routine at variety theaters in London, where performers known as "serio-comics" wore outfits and sang songs similar to Belfort's. Minnie Cunningham was one of these entertainers, along with Lizzie Aubrey, a performer at the Old Vic who was known as "la Petite Serio-Comic," a French nickname used in the London press.[3] Aubrey appeared in an etching by Lautrec's contemporary and follower Théodore van Rysselberghe (fig. 24). The work suggests the influence of Lautrec, especially in the silhouetted hats of the audience, although its perspective is not as dramatic as that taken by Lautrec in lithographs of Belfort onstage with her cat (pls. 36 and 37). To enliven his compositions, Lautrec borrowed the device of shifting

Fig. 24. Théodore van
Rysselberge (Belgian,
1862–1926), *Café-Concert*,
1897

sightlines from Edgar Degas and from Japanese
woodblock prints, evoking the dynamism of a
live performance in a modern space.

Belfort's signature act was her recitation
of the ditty "Daddy Wouldn't Buy Me a Bow-
Wow." The song was premiered in a London
music hall in 1892 by a Miss Vesta Victoria,
who also carried a cat during her performance.
The song's most famous line was "I've got
a little cat, and I'm very fond of that, but I'd
rather have a bow-wow-wow, bow-wow-wow."
The sexual overtones are obvious, with the
references to genitalia ("cat" for female and
"bow-wow" for male) in lightly coded slang.[4]
Belfort's performance of the song — she

"meowed" her lines — played to her reputation
for experimentation with same-sex lovers.

The curled tail of Belfort's black cat is a
suggestive feature of the poster she commis-
sioned from Lautrec for her appearance at
the Petit Casino (pl. 40). Her close friend and
possible lover, May Milton, commissioned a
poster from the artist around the same time,
and he seems to have designed them as a
pair, in similar sizes and complementary
colors, perhaps as an acknowledgment of their
relationship (fig. 25). May Milton, who also
came from Ireland, appears in a number of
works by Lautrec, including an illustration for
a song in which Cupid sings, "I help Sapphic
loves, women who have no male lovers."[5]

Lautrec and Belfort became friends and
social companions. They spent time together
at one of his favorite spots, the chic Irish
and American Bar on the Rue Royale; in an
inscription on a print of Belfort in an elegant
ensemble at the bar, Lautrec claimed to have
"tormented" her, perhaps by making her pose
for him (pl. 41). Very different in affect from his
images of her onstage, the lithograph provides
a glimpse of her alternate identity as a fashion-
able Parisian woman. Lautrec also created a
menu card for one of Belfort's soirées, with her
signature black cat chasing a mouse through
his monogram, and designed a holiday card for
1896 with a minstrel singer in blackface playing
a banjo along with the cat. Belfort remained a
celebrity long after Lautrec's death, performing
in music halls in London and making waves in
the press with her brief and dramatic engage-
ment to General Ben Viljoen, a renowned
veteran of the Boer wars.[6] — H B

Fig. 25. *May Milton*, 1895

36

May Belfort

1895

The performer appears onstage in her provocative baby-doll outfit, holding a black cat.

37

May Belfort

1895

A variation of the print reproduced in plate 36, in which the shifting perspective swoops down to the orchestra pit and up to the stage.

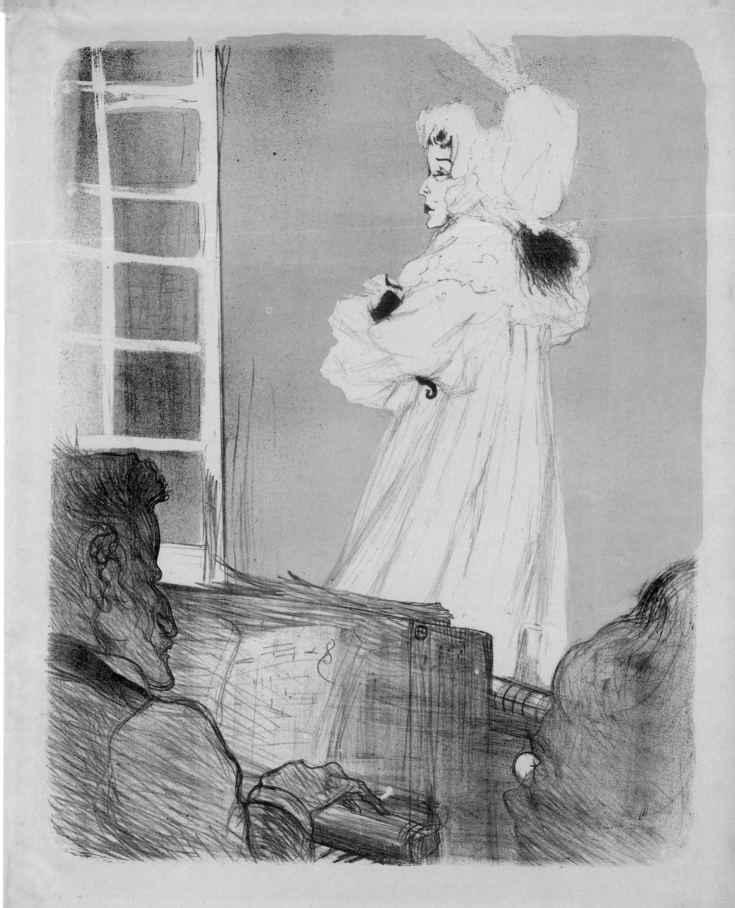

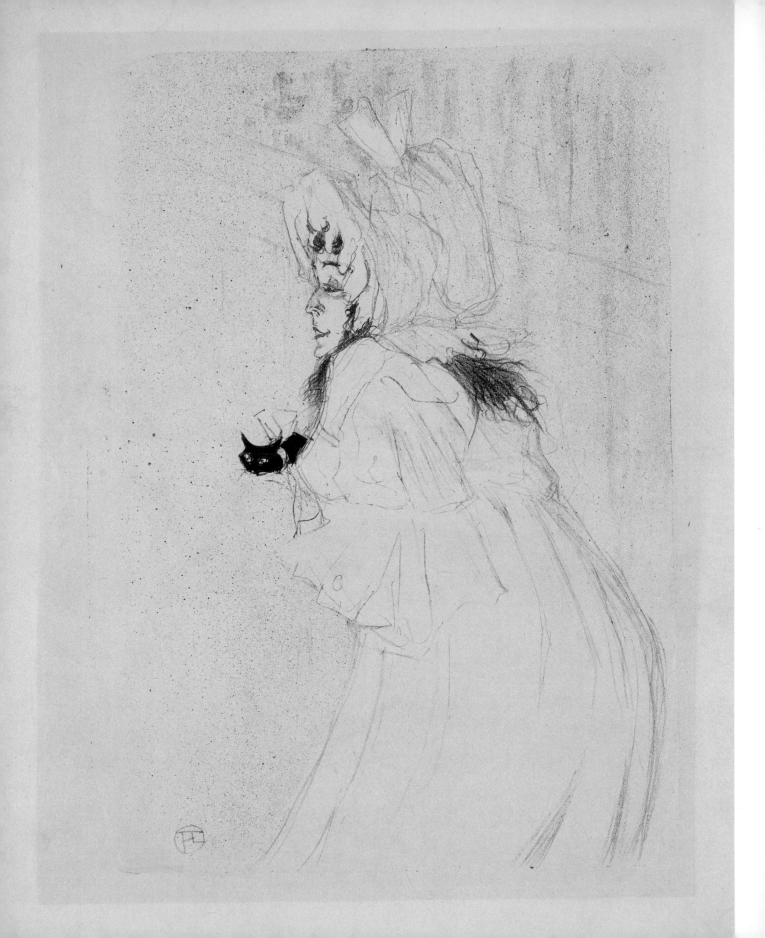

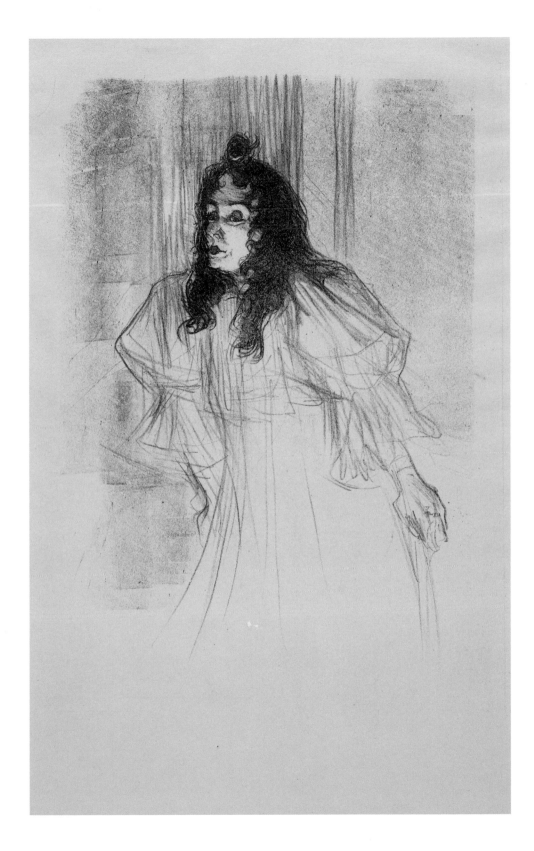

38

**May Belfort Taking
a Curtain Call**

1895

39

**May Belfort with Her
Hair Down**

1895

Cascading brown locks were
part of Belfort's signature look,
declared "absolutely charming
and as ravishing as possible"
by at least one critic.

40

May Belfort

1895

Belfort commissioned this poster from Lautrec for her appearance at the Petit Casino. He designed the lettering to harmonize with the image.

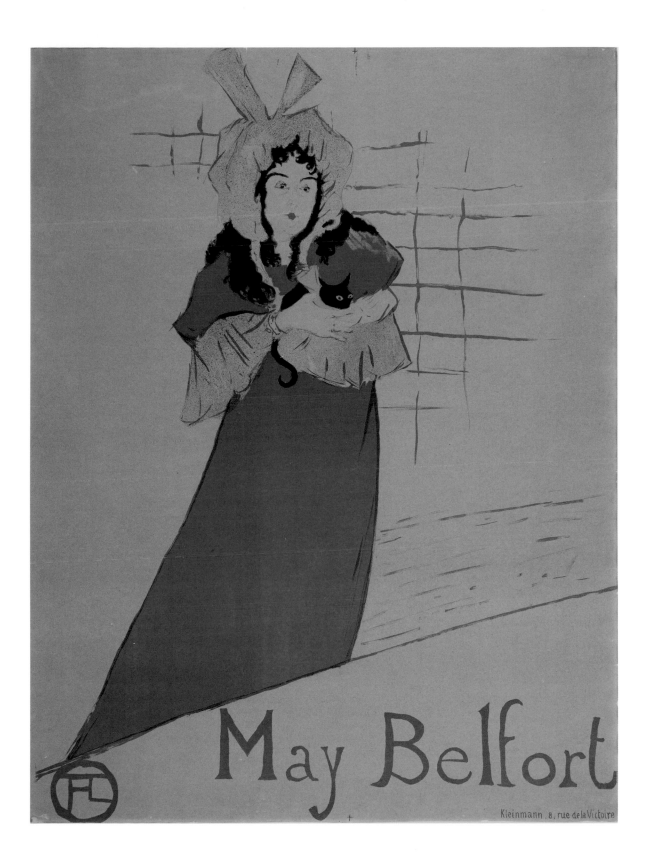

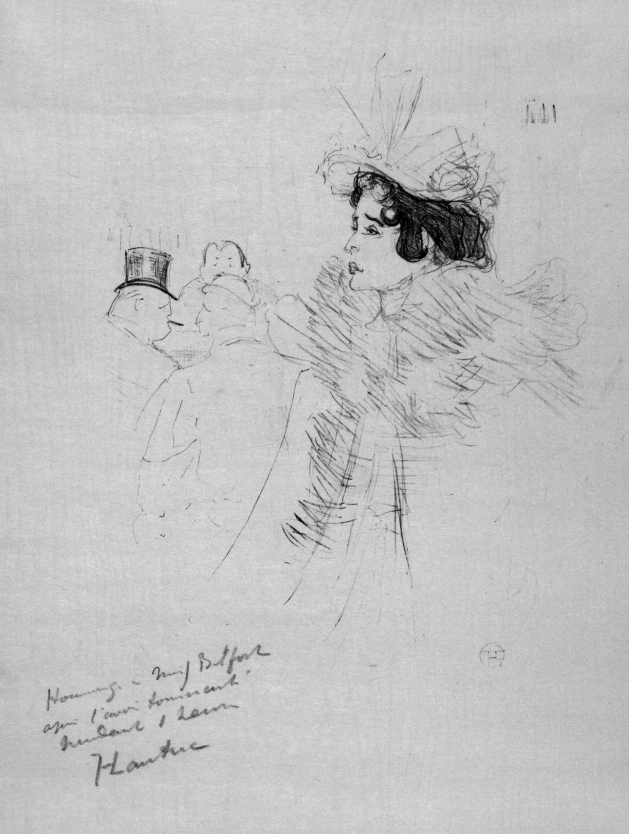

41

May Belfort at the Irish and American Bar, Rue Royale
1895

Lautrec inscribed this print: "Homage to May Belfort after having tormented her for an hour." The Irish and American Bar was a popular spot for racing fans and expatriates like Belfort, as well as for Anglophiles like Lautrec, who enjoyed speaking English and eating roast beef.

42

May Belfort
1898

This print is from the lithograph portfolio *Portraits of Actors and Actresses*. In the glare of stage light, Belfort's face and costume appear as a series of dramatic shapes, punctuated by squiggly lines. Lautrec sketched the shadowy background with broad strokes made using the side of the lithography crayon.

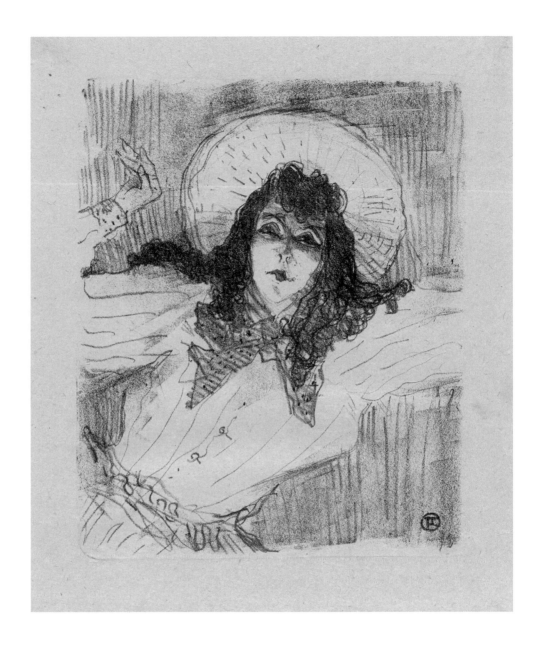

Loïe Fuller

"PARIS! PARIS! AT LAST PARIS! . . . I thought in my simplicity that I was going to conquer this great Paris that I had so long coveted."[1] With these words, the dancer Loïe Fuller (1862–1928) recalled her arrival in the city in 1892. Her prophecy turned out to be correct: Fuller become a dance sensation as well as a celebrity whose friends included such cultural titans as the sculptor Auguste Rodin, the astronomer Camille Flammarion, and the physicist Marie Curie; the poet Stéphane Mallarmé considered her his muse.

When Lautrec first encountered Fuller, she was just beginning her ascent to fame. Born and raised near Chicago, she had initially tried her luck as an actress in New York before her breakthrough invention of the "serpentine dance" made her a star (fig. 26). Although she had no formal training in dance, Fuller discovered that she could create mesmerizing effects by manipulating a voluminous skirt using lightweight wands sewn into the hem, creating a swirling vortex of fabric that almost engulfed her body. Although a related act called a "skirt dance" was already popular in the 1880s, Fuller elevated it into a marvelous and entirely new kind of spectacle by projecting colored electric lights onto her costume from both sides of the stage. The effect, as one early reviewer described it, was "unique, ethereal, delicious."[2] For her debut at the Folies-Bergère in November 1892, she presented four dances: "Serpentine," "Violet," "Butterfly," and "White Dance."[3]

At least seventy artists depicted Fuller in their work, making her one of the most frequently portrayed women of her time.[4] Her career coincided with the emergence of Art Nouveau in Paris: the sinuous lines and shapes created by her skirts, which evoked flowers, insects, and other natural forms, made her an irresistible subject for many artists and designers working in that style. Raoul Larche's elegant bronze sculpture, which was also produced as a lamp, epitomizes the Art Nouveau response to Fuller (fig. 27). At the 1900 Paris World's Fair, Fuller received her own Art Nouveau–style theater, featuring a white plaster façade that imitated the sweeping curves of her skirts and an interior lit by sunlight through colored stained glass during the day and electricity at night. Art Nouveau artists frequently drew inspiration from Japanese woodblock prints, and a poster designed by Emmanuel-Joseph-Raphael Orazi as an advertisement for Fuller's theater reveals their influence in its long, scroll-like format and its use of Japanese-style emblems (fig. 28).[5] Fuller, who had a keen eye for publicity, commissioned at least thirty posters of herself, three of them by the leading poster designer Jules Chéret. He depicted his short and somewhat stocky subject as slim and alluring, and emphasized the erotic aspects of her performance by implying that viewers could glimpse her nude body through her swirling costume.

Lautrec first saw Fuller in 1892 at the Folies-Bergère and was as captivated as the rest of Paris. Although Fuller was the only "star" he portrayed with whom he did not have a personal acquaintance, he was nonetheless inspired to create a lithograph based on her performance, which exists in about sixty unique impressions, each one in a different combination of colors (pls. 43–48).[6] Fuller appears onstage with her body engulfed in a buoyant cloud of fabric, her head, ankles, and feet peeking out coyly. Barely visible at right is the diagonal profile of the neck of a double bass protruding from the orchestra pit, a compositional device that also appears in a poster of Jane Avril at the Jardin de Paris (pl. 16). The publisher André Marty probably persuaded

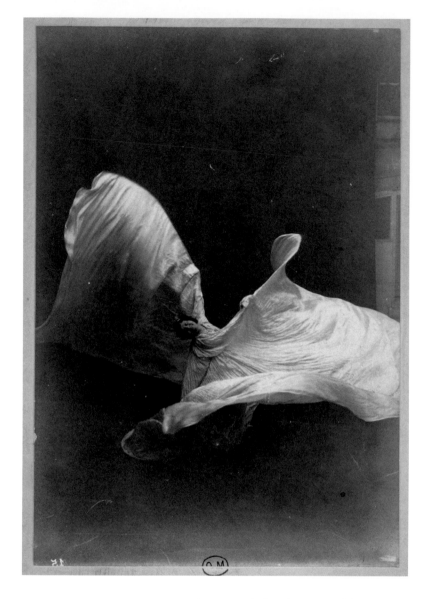

multiple colors on one stone occurs in only two other prints by the artist (including *Jane Avril*; see pl. 20). Inspired by the use of mica and brass powder in Japanese woodblock prints, he touched the fifth and final stone with a pouch filled with gold or silver powder, creating a subtly incandescent finish that alluded to the dazzling lighting effects of Fuller's performances. He may also have looked to images of Japanese actors engulfed in voluminous robes, in some cases performing vigorous movements that obscure their bodies.[8]

Fuller's performances spawned an entire genre of early cinema, "Serpentines," consisting of an often anonymous performer enacting a Fuller-style dance. A surviving hand-colored film by the Lumière Brothers, performed by one of Fuller's many imitators, gives the best

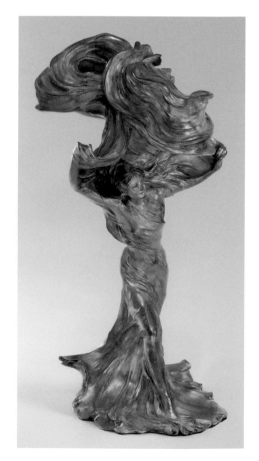

Fig. 26. Isaiah West Taber (American, 1830–1912), *Loïe Fuller Dancing with Her Veil*, about 1900

Fig. 27. François-Raoul Larche (French, 1860–1912), *Loïe Fuller, the Dancer (Paris World's Fair, 1900)*, about 1909

Lautrec to design the center of the composition to fit the window of a pale-blue decorative mat embellished with wavy lines and petal-like shapes in gold.[7]

Working closely with a professional printer, the artist created each impression from five stones. The first three stones each printed in the same color for each impression. On the fourth stone, Lautrec applied different combinations of red, brown, violet, blue, yellow, and green inks. The unusual technique of using

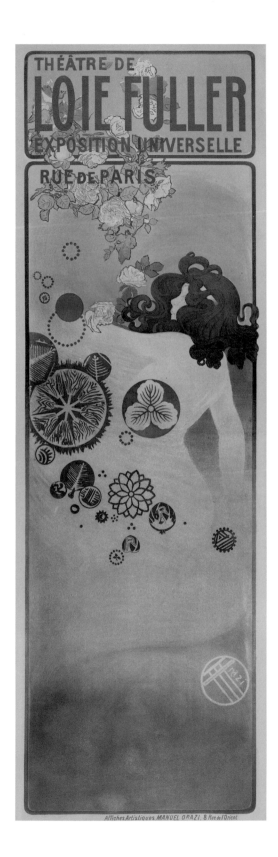

approximation of what Fuller's performances may have looked like.[9] In the sheer variety of their colors, Lautrec's lithographs come closer than any other depiction of Fuller to approximating the proto-cinematic nature of her performance. A witness to Fuller's debut at the Folies-Bergère in 1892 described the astonishing effects of colored electric lights upon her voluminous robes as she danced within the darkened theater: "In rapid and curious transformations, these veils change color several times; sometimes it is the azure of the sky, sometimes the emerald of the seas, sometimes the bright red of a fire, then dead hues, faded violets, yellows of exquisite pallor."[10]

While Lautrec tried to capture characteristic gestures and expressions of such performers as Yvette Guilbert and Jane Avril, his lithograph of Fuller shows how her performances displaced gesture away from the body and onto the fabric of her skirts. Perhaps what appealed to the artist was the transcendence that Fuller's performance evoked, as her body was dematerialized through moving fabric and colored light. Her upturned face, with its rapturous expression, captures the freedom of Fuller's performance and perhaps reflects a longing for liberation from bodily reality in the artist himself.

It is still not known exactly how Lautrec produced the remarkable color effects found in his lithographs of Fuller; scholars have proposed at least three different explanations.[11] Just as Fuller's stage-lighting process remained a mystery to her viewers, Lautrec's method remains equally mysterious to viewers today. There is a fitting congruence between the technical dazzle of her show and the technical mystery of his printing process. This series conveys a flicker of the ecstatic wonder that Fuller's viewers must have felt when she first appeared in a cloud of colored lights. — JW

Fig. 28. Emmanuel-Joseph-Raphael Orazi (Italian, 1860–1934), *Loïe Fuller*, 1900

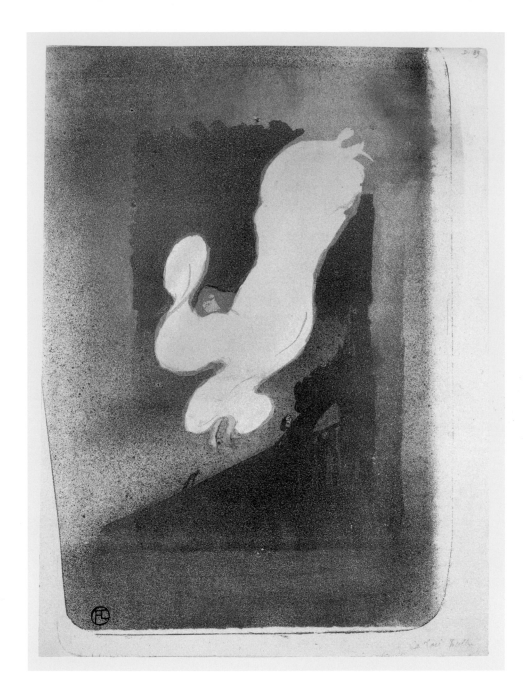

43

Loïe Fuller

1893

These six impressions (of a total of about sixty) of Loïe Fuller represent Lautrec's inspired attempts to capture the range of evanescent colors seen in Fuller's performances. Each impression, printed from five stones, features a unique combination of colors.

44

Loïe Fuller

1893

This impression is signed by the artist and dedicated "to Stern," like many of Toulouse-Lautrec's proofs, or test prints. Henri Stern was a printer who worked closely with the artist.

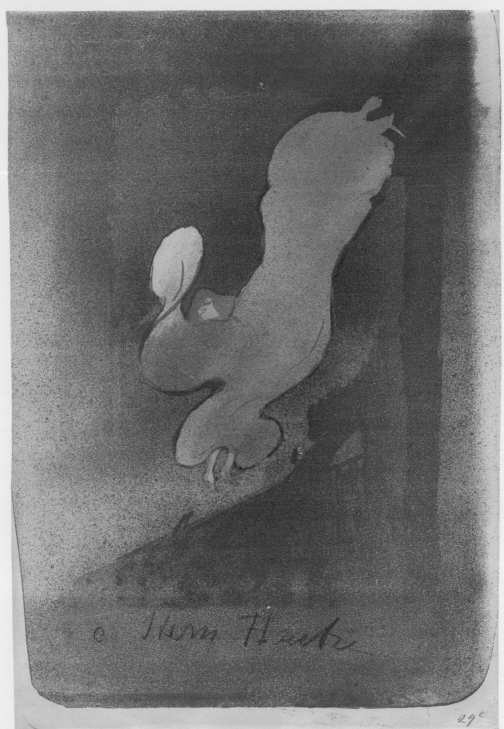

Herr Haste

29c

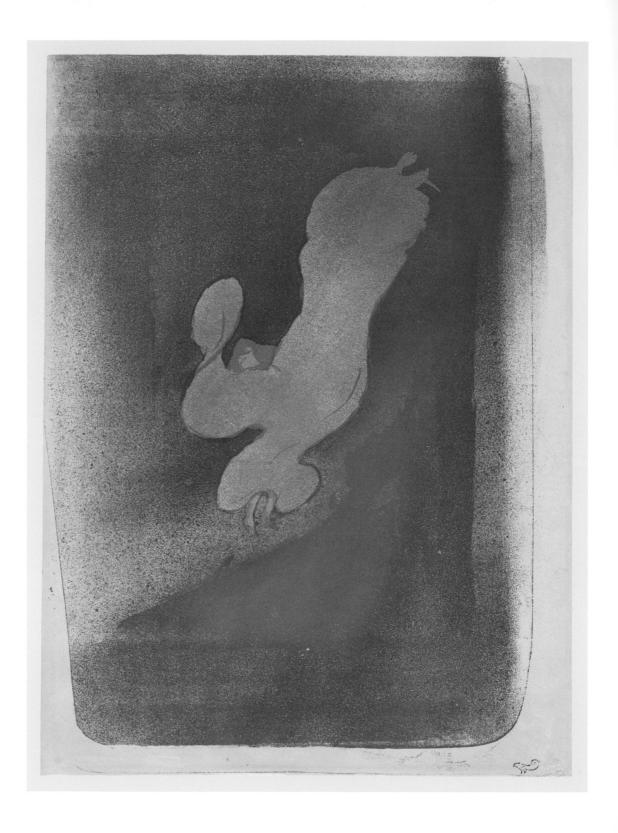

45
Loïe Fuller
1893

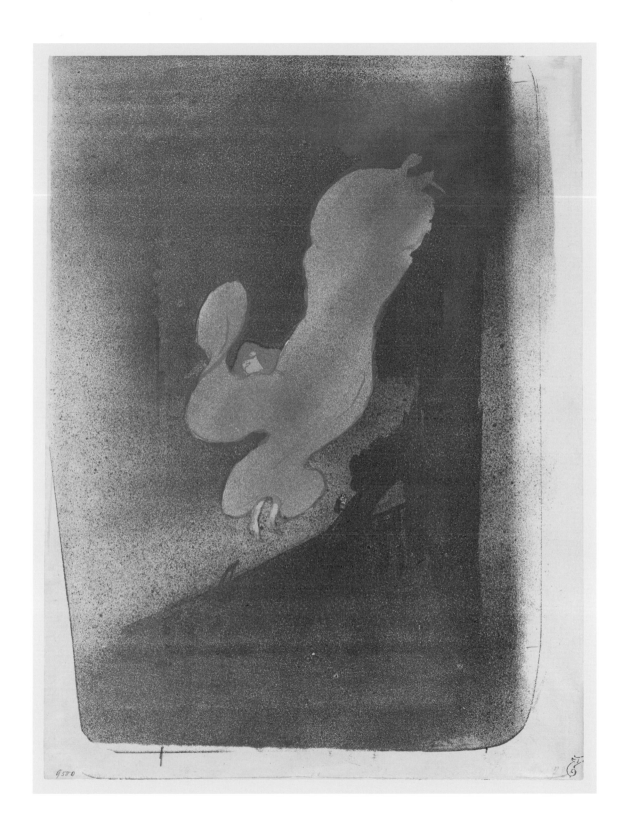

46
Loïe Fuller
1893

47
Loïe Fuller
1893

48

Loïe Fuller

1893

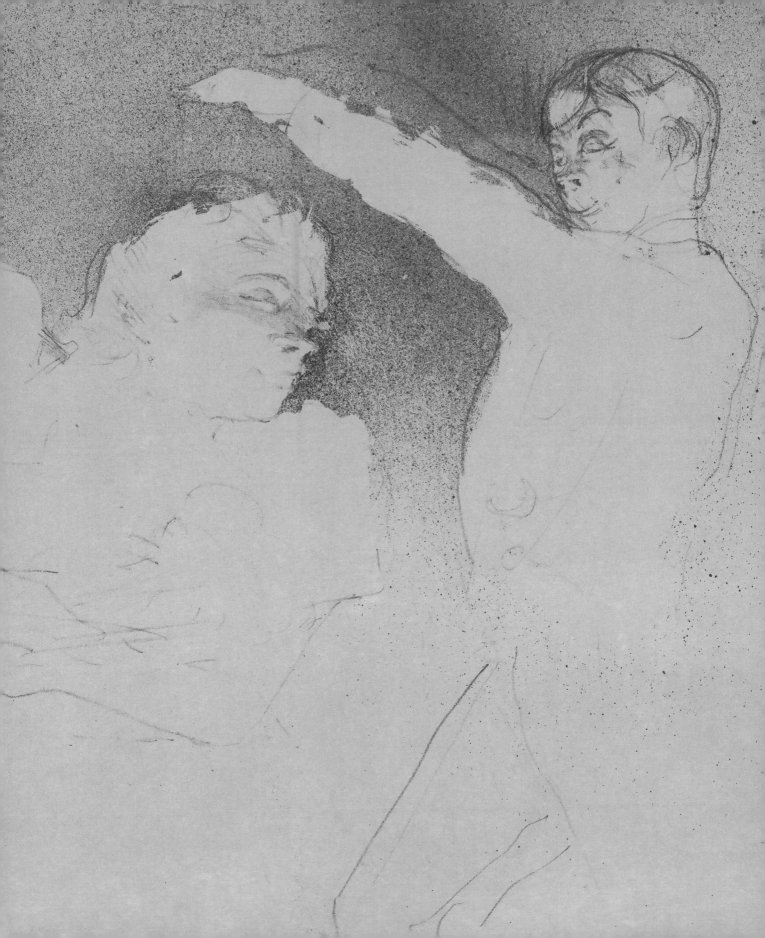

Notes

Foreword

1. Aspiring stars "lacked for nothing in terms of publicity: reporters have interviewed them and written their biographies; their portraits have been distributed; large-format posters made by followers of [Jules] Chéret have announced their venue to the world; prospectuses, announcements, gossip columns, publicity carts, sandwich-board men, illuminated signs, lighted columns where their names flame in letters of fire in the night of the boulevards, their merits shouted out, announced with a trumpet blast to Paris, in the provinces, even abroad: everything has been put in place!" Jules Roques, "Pour les aspirantes-étoiles," *Le Courrier Français*, June 1892, p. 3. For full discussion of Lautrec and celebrity culture, see Mary Weaver Chapin, "Henri de Toulouse-Lautrec and the Café-Concert: Printmaking, Publicity, and Celebrity in Fin-de-Siècle Paris" (PhD diss., Institute of Fine Arts, New York University, 2002).

2. Arsène Alexandre, "Chroniques d'aujourd'hui: H. de Toulouse-Lautrec," *Le Paris*, January 8, 1892, as quoted in Gale Murray, *Toulouse-Lautrec: A Retrospective* (New York: Hugh Lauter Levin Associates, 1992), 140–41; Ernest Maindron, *Affiches illustrées: 1886–1895* (Paris: G. Boudet, 1896), 110.

3. The art critic Alexander Brook noted, "In viewing Lautrec's pictures it is like meeting the personalities themselves. More than that, one seems to have met them before. Is it possible that Lautrec, who knew most of his models so well, implanted in his work this intimacy which in turn reaches us?" *The Arts* 4, no. 3 (September 1923): 137.

4. Gustave Coquiot, *Des peintres maudits* (Paris: André Delpeuch, 1924), 76.

Introduction

1. Julia Frey, *Toulouse-Lautrec: A Life* (London: Weidenfeld and Nicolson, 1994). The artist may have suffered from the bone disease pycnodysostosis, also known as Toulouse-Lautrec syndrome, a condition linked to a recessive gene that was identified in 1996.

2. Richard Thomson, in Richard Thomson, Phillip Dennis Cate, and Mary Weaver Chapin, *Toulouse-Lautrec and Montmartre* (Washington, D.C.: National Gallery of Art; Princeton: Princeton University Press, 2005), 14–15; and Thomson in Claire Frèches-Thory et al., *Toulouse-Lautrec* (London: South Bank Centre; Paris: Réunion des Musées Nationaux, 1991), 23–25.

3. On the identification of the female sitter, see Rudolf Koella et al., *Toulouse-Lautrec und die Photographie* (Bern: Kunstmuseum, 2015), 119.

4. Thomson in *Toulouse-Lautrec and Montmartre*, 14–15: "un mie" (slang for "amie") referred to a lower-class woman; "un miché à la mie" was a term for a client who fails to pay a prostitute.

5. "'Decent' women were never seen in public drinking alcohol": Ingrid Pfeiffer and Max Hollein, eds., *Esprit Montmartre: Bohemian Life in Paris around 1900* (Frankfurt: Schirn Kunsthalle, 2014), 30.

6. Théodore Duret, *Lautrec* (Paris: Bernheim-Jeune & Cie, 1920), 64.

7. "An extreme form of the cancan, frenetic and salacious": Richard Thomson in *Toulouse-Lautrec: The Complete Prints*, by Wolfgang Wittrock (London: Sotheby's Publications, 1985), vol. 1, p. 19.

8. See the discussion of the poster *France: Champagne* (1891), by Pierre Bonnard, in Mary Weaver Chapin, *Posters of Paris: Toulouse-Lautrec and His Contemporaries* (Milwaukee: Milwaukee Art Museum, 2012), 24–25.

9. Mary Weaver Chapin in Thomson et al., *Toulouse-Lautrec and Montmartre*, 91.

10. On the poster craze and the new Paris, see Chapin, *Posters of Paris*, 13–21, and Jeannine Falino, *L'Affichomania: The Passion for French Posters* (Chicago: Driehaus Museum, 2017).

11. Chapin, *Posters of Paris*, 17–18.

12. See Antony Griffiths in Wittrock, *Toulouse-Lautrec: The Complete Prints*, p. 36. On lithography in the period, see also Christine Giviskos and Jane Voorhees, *Set in Stone: Lithography in Paris, 1815–1900* (New Brunswick, N.J.: Zimmerli Art Museum; Munich: Hirmer, 2018); Douglas Druick and Peter Zegers, *La Pierre Parle: Lithography in France, 1848–1900* (Ottawa:

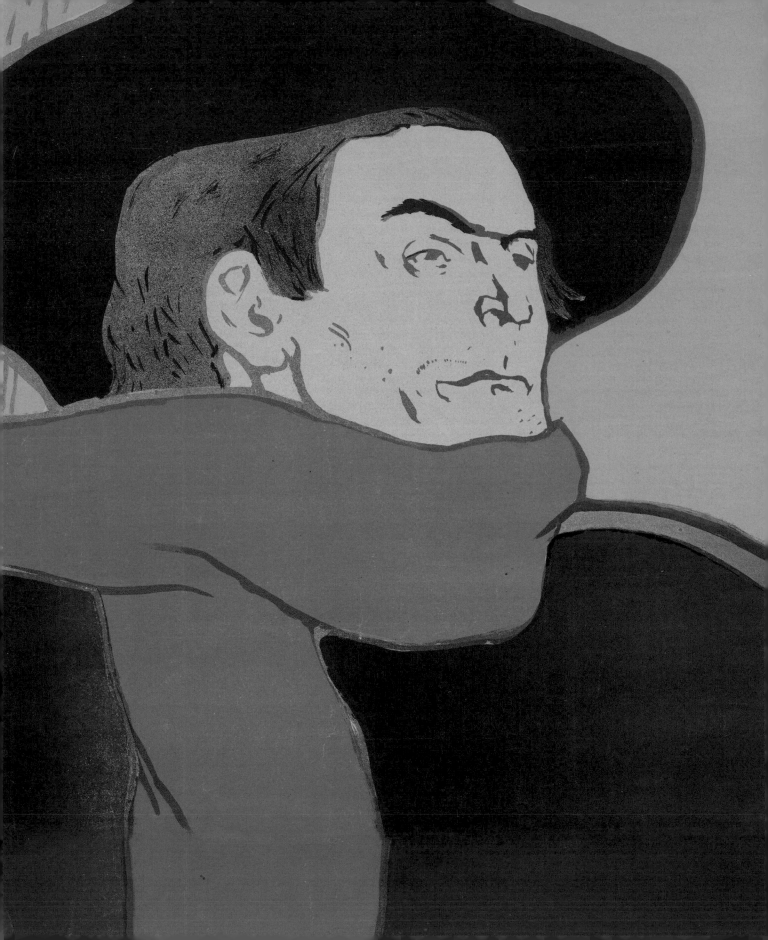

List of Illustrations

Works are by Henri de Toulouse-Lautrec and their medium is lithography, unless otherwise noted. Print dimensions given are the size of the sheet.

Plates

1
Yvette Guilbert, 1893
From the portfolio *The Café-Concert*
43.7 x 31.7 cm (17¼ x 12½ in.)
Museum of Fine Arts, Boston
Bequest of W. G. Russell Allen, 1960, 60.751

2
Cover
From the first *Yvette Guilbert* album, 1894
40 x 43 cm (15¾ x 17 in.)
Boston Public Library
Albert H. Wiggin Collection, 1941

3
Third plate
From the first *Yvette Guilbert* album, 1894
38 x 38 cm (14⅞ x 14⅞ in.)
Boston Public Library
Albert H. Wiggin Collection, 1941

4
Fourth plate
From the first *Yvette Guilbert* album, 1894
38 x 38 cm (14⅞ x 14⅞ in.)
Boston Public Library
Albert H. Wiggin Collection, 1941

5
Tenth plate
From the first *Yvette Guilbert* album, 1894
38 x 38 cm (14⅞ x 14⅞ in.)
Boston Public Library
Albert H. Wiggin Collection, 1941

6
Sixteenth plate
From the first *Yvette Guilbert* album, 1894
38 x 38 cm (14⅞ x 14⅞ in.)
Boston Public Library
Albert H. Wiggin Collection, 1941

7
Frontispiece
From the second *Yvette Guilbert* album
(English Series), 1898
50 x 37 cm (19⅝ x 14½ in.)
Boston Public Library
Albert H. Wiggin Collection, 1941

8
Fallen for It
From the second *Yvette Guilbert* album
(English Series), 1898
50 x 38 cm (19⅝ x 14⅞ in.)
Boston Public Library
Albert H. Wiggin Collection, 1941

9
On Stage
From the second *Yvette Guilbert* album
(English Series), 1898
50 x 38 cm (19⅝ x 14⅞ in.)
Boston Public Library
Albert H. Wiggin Collection, 1941

10
Linger, Longer, Loo
From the second *Yvette Guilbert* album
(English Series), 1898
50 x 38 cm (19⅝ x 14⅞ in.)
Boston Public Library
Albert H. Wiggin Collection, 1941

11
Greeting the Public
From the second *Yvette Guilbert* album
(English Series), 1898
50 x 38 cm (19⅝ x 14⅞ in.)
Boston Public Library
Albert H. Wiggin Collection, 1941

12
Divan Japonais, 1893
81 x 62.3 cm (31⅞ x 24½ in.)
Museum of Fine Arts, Boston
Lee M. Friedman Fund, 68.721

13
Divan Japonais, 1893
80.4 x 62.3 cm (31⅝ x 24½ in.)
Museum of Fine Arts, Boston
Lee M. Friedman Fund, 68.723

14
Divan Japonais, 1893
80.4 x 62.2 cm (31⅝ x 24½ in.)
Museum of Fine Arts, Boston
Lee M. Friedman Fund, 68.724

15
Divan Japonais, 1893
80.4 x 62.2 cm (31⅝ x 24½ in.)
Museum of Fine Arts, Boston
Lee M. Friedman Fund, 68.722

16
Jane Avril (Jardin de Paris), 1893
129.1 x 93.5 cm (50 7.8 x 36¾ in.)
The Metropolitan Museum of Art
Harris Brisbane Dick Fund, 1932, 32.88.15
Image © The Metropolitan Museum of Art;
image source: Art Resource, NY

17
Cover of the portfolio *The Original Print
(L'Estampe Originale)*, 1893
58.1 x 83.2 cm (22⅞ x 32¾ in.)
Museum of Fine Arts, Boston
Bequest of W. G. Russell Allen, 60.747

18
Jane Avril, 1893
From the portfolio *The Café-Concert*
43.3 x 31.6 cm (17 x 12½ in.)
Museum of Fine Arts, Boston
Bequest of W. G. Russell Allen, 60.750

19
Mademoiselle Églantine's Troupe, 1896
63 x 80 cm (24⅞ x 31½ in.)
Boston Public Library
Albert H. Wiggin Collection, 1941

20
Jane Avril, 1899
56 x 38 cm (22 x 15 in.)
Boston Public Library
Albert H. Wiggin Collection, 1941

21
Ambassadeurs: Aristide Bruant in His Cabaret,
1892
142 x 95 cm (55⅞ x 37⅜ in.)
Harvard Art Museums/Fogg Museum
Gift of the Rubin-Ladd Foundation, 2014.413
Photograph: Imaging Department,
© President and Fellows of Harvard College

22
Eldorado: Aristide Bruant in His Cabaret, 1892
149.2 x 97.5 cm (58¾ x 38⅜ in.)
Boston Public Library
Albert H. Wiggin Collection, 1941

23
Aristide Bruant in His Cabaret, 1893
138.4 x 96.5 cm (54½ x 38 in.)
Museum of Fine Arts, Boston
Otis Norcross Fund, 56.1190

24
Aristide Bruant in His Cabaret, 1893
135.9 x 97.8 cm (53½ x 38½ in.)
Boston Public Library
Albert H. Wiggin Collection, 1941

25
Aristide Bruant, 1893
From the portfolio *The Café-Concert*
44 x 31.3 cm (17¼ x 12¼ in.)
Museum of Fine Arts, Boston
Bequest of W. G. Russell Allen, 60.756

26
Aristide Bruant (Bruant at the Mirliton), 1893
80 x 60 cm (31½ x 23⅝ in.)
Boston Public Library
Albert H. Wiggin Collection, 1941

27
*Aristide Bruant (The Second Volume by
Bruant)*, 1893
82 x 61 cm (32¼ x 24 in.)
Boston Public Library
Albert H. Wiggin Collection, 1941

28
*At the Variétés: Marcelle Lender and Albert
Brasseur*, 1893
46 x 31 cm (18⅛ x 12¼ in.)
Boston Public Library
Albert H. Wiggin Collection, 1941

29
*At the Variétés: Marcelle Lender and Albert
Brasseur*, 1893
38 x 27 cm (15 x 10⅝ in.)
Boston Public Library
Albert H. Wiggin Collection, 1941

30
Marcelle Lender and Baron (Louis Bouchené),
1893
38 x 28 cm (15 x 11 in.)
Boston Public Library
Albert H. Wiggin Collection, 1941

31
Marcelle Lender in Madame Satan, 1893
38 x 28 cm (15 x 11 in.)
Boston Public Library
Albert H. Wiggin Collection, 1941

32
Marcelle Lender Dancing the Bolero in
Chilpéric, 1895
52 x 41 cm (20½ x 16⅛ in.)
Boston Public Library
Albert H. Wiggin Collection, 1941

33
Marcelle Lender in Chilpéric, *Facing Forward*,
1895
51 x 40 cm (20⅛ x 15¾ in.)
Boston Public Library
Albert H. Wiggin Collection, 1941

34
Marcelle Lender Dancing the Bolero in
Chilpéric, *from Behind*, 1895
55 x 39 cm (21⅝ x 15⅜ in.)
Boston Public Library
Albert H. Wiggin Collection, 1941

35
Marcelle Lender, 1895
50.8 x 38.4 cm (20 x 15⅛ in.)
Museum of Fine Arts, Boston
Bequest of Keith McLeod, 52.1529

36
May Belfort, 1895
57 x 45.7 cm (22½ x 18 in.)
Museum of Fine Arts, Boston
Museum purchase with funds donated by
Mrs. Charles Gaston Smith's Group, 32.493

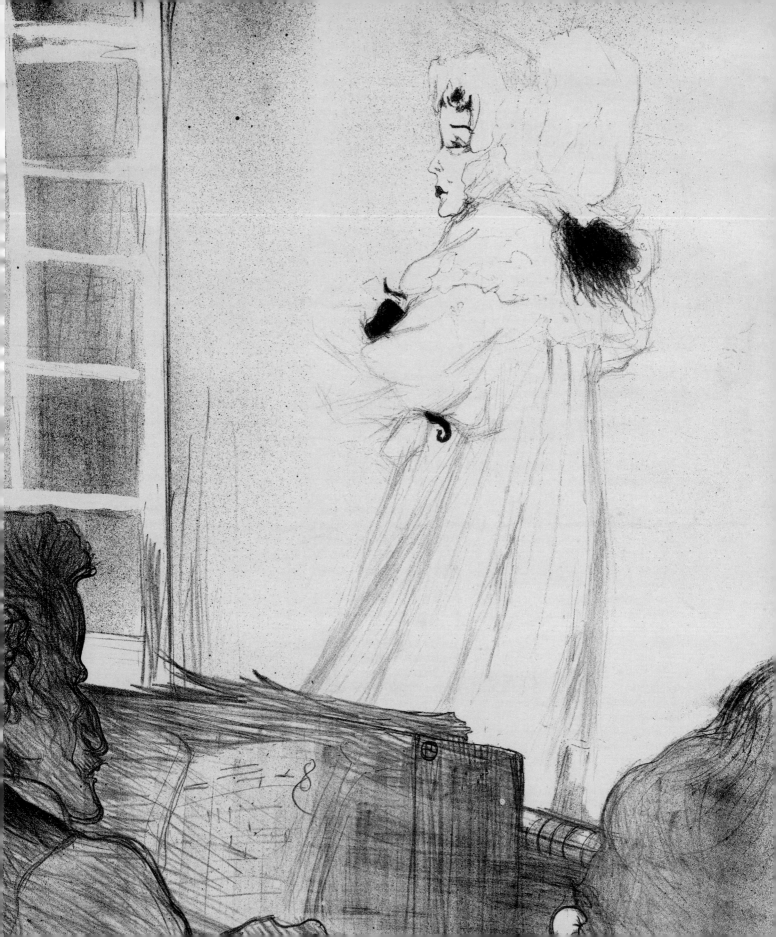

Further Reading

Adriani, Götz. *Toulouse-Lautrec: The Complete Graphic Works. A Catalogue Raisonné — The Gerstenberg Collection.* London: Thames and Hudson, 1988.

Castleman, Riva, and Wolfgang Wittrock, eds. *Henri de Toulouse-Lautrec: Images of the 1890s.* New York: Museum of Modern Art, 1985.

Cate, Philip Dennis, and Mary Shaw, eds. *The Spirit of Montmartre: Cabarets, Humor, and the Avant-Garde, 1875–1905.* New Brunswick, N.J.: Zimmerli Art Museum, 1996.

Childs, Elizabeth, ed. *Spectacle and Leisure in Paris: Degas to Mucha.* St. Louis: Mildred Lane Kemper Art Museum, 2017.

Denvir, Bernard. *Toulouse-Lautrec.* London: Thames and Hudson, 1991.

Frey, Julia. *Toulouse-Lautrec: A Life.* New York: Viking, 1994.

Giviskos, Christine, and Jane Voorhees. *Set in Stone: Lithography in Paris, 1815–1900.* New Brunswick, N.J.: Zimmerli Art Museum; Munich: Hirmer, 2018.

Ives, Colta. *Toulouse-Lautrec in the Metropolitan Museum of Art.* New York: Metropolitan Museum of Art, 1996.

Murray, Gale Barbara, ed. *Toulouse-Lautrec: A Retrospective.* New York: Hugh Lauter Levin Associates, 1992.

Pfeiffer, Ingrid, and Max Hollein, eds. *Esprit Montmartre: Bohemian Life in Paris around 1900.* Frankfurt: Schirn Kunsthalle; Munich: Hirmer Verlag, 2014.

Shapiro, Barbara Stern, Anne Havinga, Susanna Barrows, Philip Dennis Cate, and Barbara K. Wheaton. *Pleasures of Paris: Daumier to Picasso.* Boston: Museum of Fine Arts, 1991.

Suzuki, Sarah. *The Paris of Toulouse-Lautrec: Prints and Posters from the Museum of Modern Art.* New York: Museum of Modern Art, 2014.

Rosa de Carvalho, Fleur Roos. *Prints in Paris 1900: From the Elite to the Street.* Amsterdam: Van Gogh Museum; Brussels: Mercatorfonds, 2017.

Thomson, Richard, Philip Dennis Cate, and Mary Weaver Chapin. *Toulouse-Lautrec and Montmartre.* Washington, D.C.: National Gallery of Art; Princeton: Princeton University Press, 2005.

Thomson, Richard, Claire Frèches-Thory, Anne Roquebert, and Danièle Devynck. *Toulouse-Lautrec.* London: South Bank Centre, 1991.

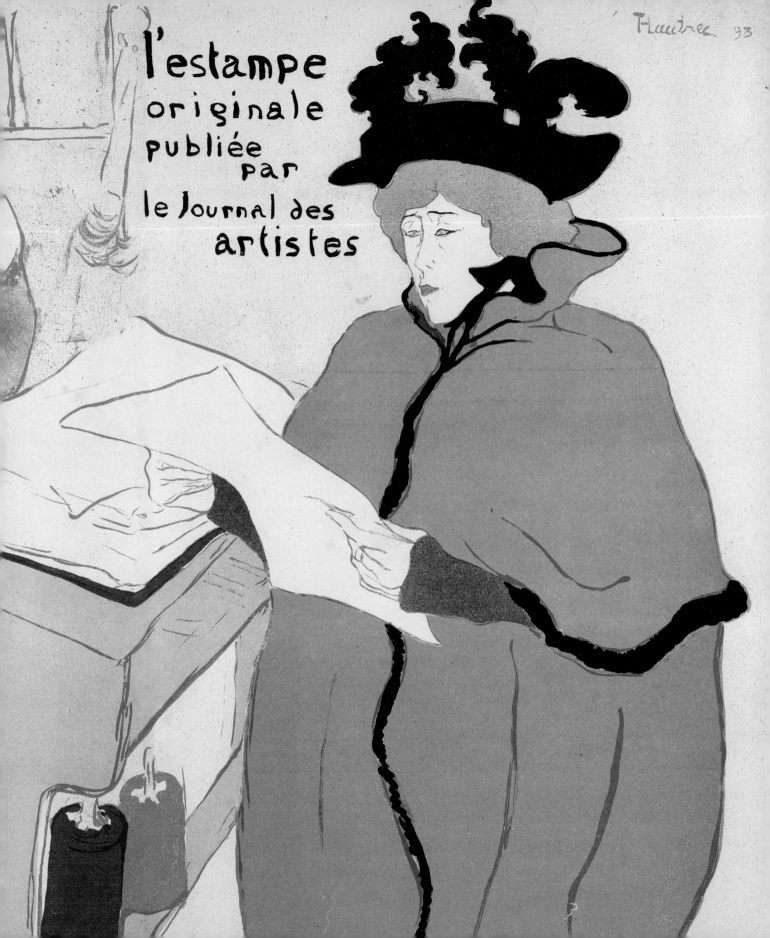

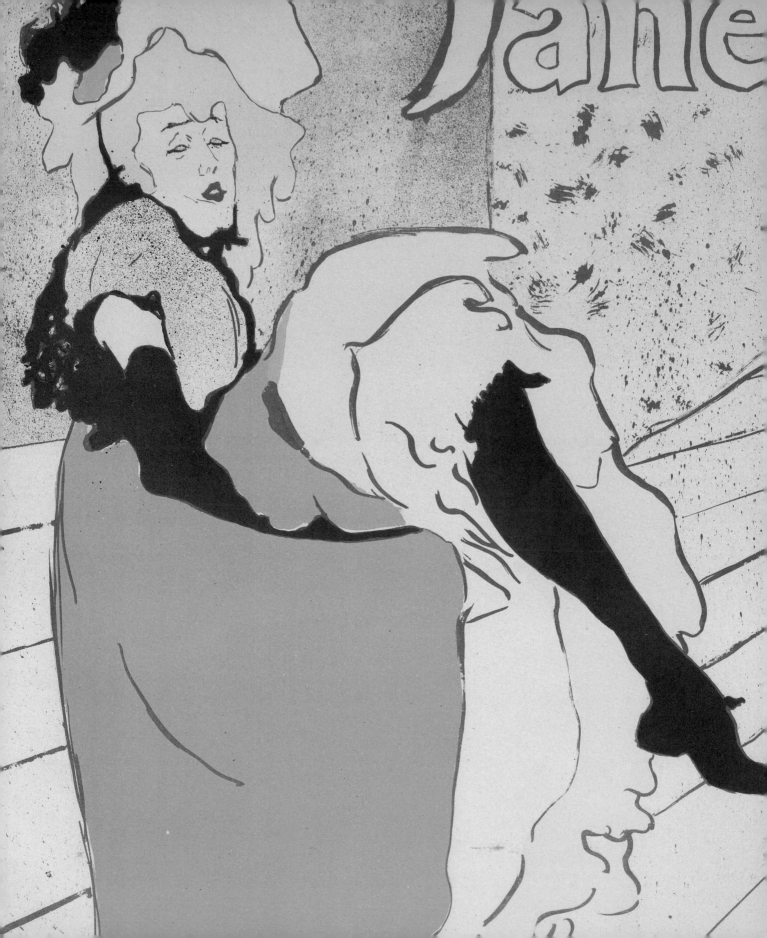

Acknowledgments

A remarkable team of dedicated colleagues ensured the success of this publication and the related exhibition. All of us at the MFA thank our partners at the Boston Public Library, especially David Leonard, President, and Beth Prindle, Jessica Bitely, Karen Shafts, Aaron Schmidt, Martha Mahard, and the Digital Services team; as well as Elizabeth Holbrook, Consulting Registrar, and Tara Huber and Terrance D'Ambrosio of the Northeast Document Conservation Center. Acknowledgment is also due to the Associates of the Boston Public Library, who have helped support the digitizing of works on paper from the Print Collection at the BPL. We are grateful to Mary Bartow and Benjamin Hanbury-Aggs of Sotheby's, as well as Molly Ott Ambler, Jack Rennert, and Georgina Kelman. We are indebted to our lenders, especially Isabelle and Scott Black, and we acknowledge the invaluable assistance of Ashley Dunn and Elizabeth Zanis of the Metropolitan Museum of Art, Elizabeth Rudy and Cassandra Albinson of the Harvard Art Museums, and Matthew Wittmann of the Houghton Library.

At the MFA, I can thank only a handful of the many colleagues who have contributed in innumerable ways. These include Matthew Teitelbaum, Ann and Graham Gund Director, as well as Edward Saywell, who envisioned the exhibition and partnership. Edward and I are indebted to Thomas E. Rassieur, who planted the idea of combining the BPL and MFA collections of Toulouse-Lautrec's works. I also thank Katie Getchell and her remarkable team, especially Dawn Griffin and Karen Frascona; and colleagues in Development, especially Patricia Doyle and Blair Hollis. Curatorial colleagues have generously lent time and expertise to this project, most notably Victoria Reed, Monica S. Sadler Curator for Provenance; Ronni Baer, William and Ann Elfers Senior Curator of Paintings, Art of Europe; Katie Hanson; Marietta Cambareri, Senior Curator of European Sculpture and Jetskalina H. Phillips Curator of Judaica; Sarah Thompson; Paul McAlpine; Clifford S. Ackley, Ruth and Carl J. Shapiro Curator of Prints and Drawings;

Meghan Melvin, Jean S. and Frederic A. Sharf Curator of Design; Genevra Higginson; Patrick Murphy, Lia and William Poorvu Assistant Curator of Prints and Drawings and Supervisor, Morse Study Room; Jeffrey Holman; Anne Havinga, Estrellita and Yousuf Karsh Chair, Department of Photography; Michelle Finamore, Penny Vinik Curator of Fashion Arts; Lauren Whitley; Emily Stoehrer, Rita J. Kaplan and Susan B. Kaplan Curator of Jewelry; and Darcy Kuronen, Department Head and Pappalardo Curator of Musical Instruments.

Ben Weiss, Director of Collections and Leonard A. Lauder Curator of Visual Culture, was as helpful as ever, as was our friend and collaborator at Hunter College, Lynda Klich. The talented editor Jennifer Snodgrass patiently shepherded this publication through every stage of production, and the book's designer, Susan Marsh, has made it an aesthetic object in its own right. Kyla Hygysician, Nick Pioggia, and Adam Tessier are the creative team who helped to shape the related exhibition, ably managed by Chris Newth and Patrick McMahon. I am indebted to the collections care staff responsible for the works on view in the exhibition and reproduced in this volume, especially Alison Luxner, Gail English, and TJ Kelly, as well as Irene Konefal, LeeAnn Gordon, Claudia Iannuccilli, Andrew Haines, Brett Angel, and Jill Kennedy-Kernohan. Special thanks to Joanna Wendel, Claire W. and Richard P. Morse Curatorial Research Fellow, Department of Prints and Drawings, who contributed to the catalogue and supported the exhibition's development in numerous ways; and to Mary Weaver Chapin, for her insightful essays in this volume, as well as for her groundbreaking research on Toulouse-Lautrec and celebrity. Finally, I would like to thank the Georges and Wesley for their support, both spectacular and subtle.

HELEN BURNHAM
Pamela and Peter Voss Curator of Prints and Drawings
Museum of Fine Arts, Boston

MFA Publications
Museum of Fine Arts, Boston
465 Huntington Avenue
Boston, Massachusetts 02115
www.mfa.org/publications

Published in conjunction with the exhibition
Toulouse-Lautrec and the Stars of Paris,
organized by the Museum of Fine Arts,
Boston, and the Boston Public Library,
April 7–August 4, 2019

Exhibition sponsored by Encore Boston
Harbor. Additional support from the great-
grandchildren of Albert H. Wiggin, the Cordover
Exhibition Fund, and anonymous funders

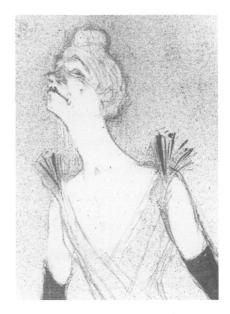

The Museum of Fine Arts, Boston, is a nonprofit
institution devoted to the promotion and
appreciation of the creative arts. The Museum
endeavors to respect the copyrights of all
authors and creators in a manner consistent
with its nonprofit educational mission. If
you feel any material has been included in
this publication improperly, please contact
the Department of Rights and Licensing at
617 267 9300, or by mail at the above address.

While the objects in this publication neces-
sarily represent only a small portion of the
MFA's holdings, the Museum is proud to be a
leader within the American museum com-
munity in sharing the objects in its collection
via its website. Currently, information about
approximately 400,000 objects is available
to the public worldwide. To learn more about
the MFA's collections, including provenance,
publication, and exhibition history, kindly visit
www.mfa.org/collections.

For a complete listing of MFA publications,
please contact the publisher at the above
address, or call 617 369 3438.

Illustrations in this book were photographed
by the Imaging Studios, Museum of Fine Arts,
Boston, except where otherwise noted.

Edited by Jennifer Snodgrass
Proofread by Fronia W. Simpson
Designed by Susan Marsh
Production by Terry McAweeney
Production assistance by Hope Stockton
and Jessica Eber
Typeset in Meta Pro by Matt Mayerchak
Printed on 150 gsm Perigord
Printed and bound at Graphicom, Verona, Italy

Distributed in the United States of America
and Canada by
ARTBOOK | D.A.P.
75 Broad Street, Suite 630
New York, New York 10004
www.artbook.com

Distributed outside the United States
of America and Canada by
Thames & Hudson, Ltd.
181A High Holborn
London WC1V 7QX
www.thamesandhudson.com

FIRST EDITION

Printed and bound in Italy
This book was printed on acid-free paper.

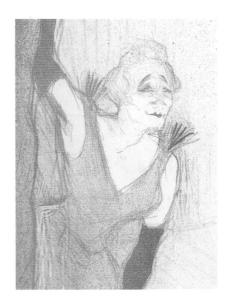